Desert Light

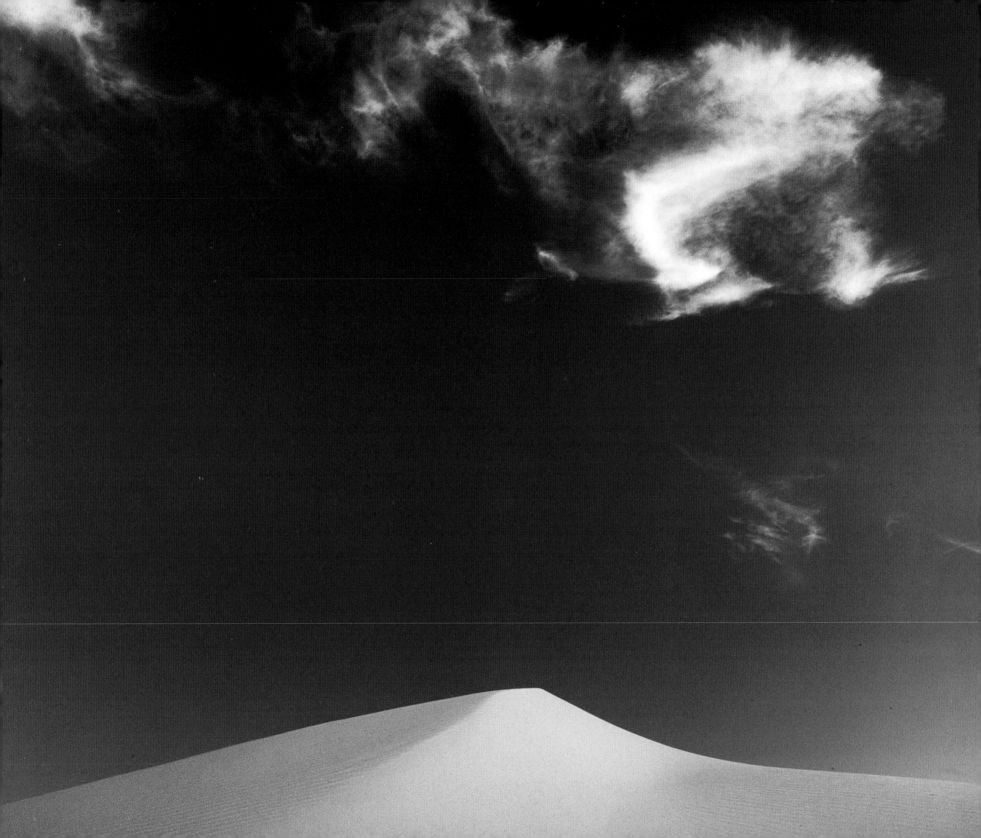

Desert Light

A Photographer's Journey
through America's Desert Southwest

JOHN ANNERINO

THE COUNTRYMAN PRESS
Woodstock, Vermont

Essays and photographs copyright © 2006 by John Annerino

First Edition

ISBN-13: 978-0-88150-682-2
ISBN-10: 0-88150-682-6

Library of Congress Cataloging-in-Publication Data has been applied for.

Book design and composition by Susan McClellan
Cartography by Jacques Chazaud

Published by The Countryman Press
P.O. Box 748, Woodstock, VT 05091

Distributed by W. W. Norton & Company, Inc.
500 Fifth Avenue, New York, NY 10110

Printed in Spain by Artes Graficas Toledo

10 9 8 7 6 5 4 3 2 1

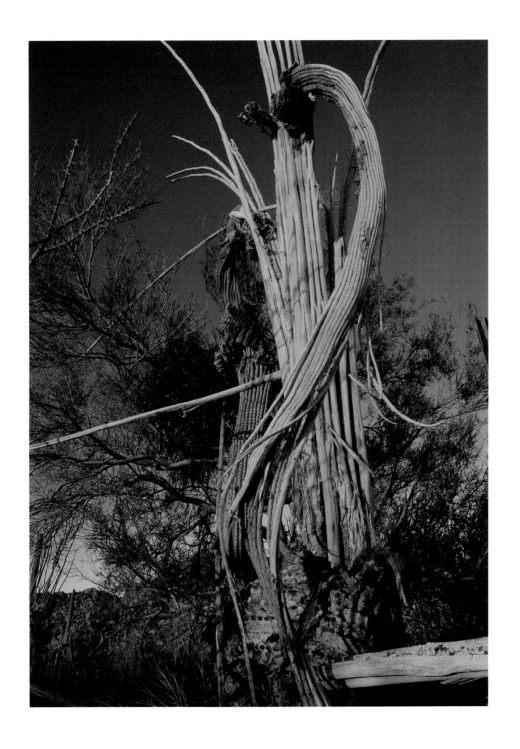

For Chico Shuni—
the last of the desert-dwelling Sand Pápago.
He held their ground to the last man.

◄ Saguaro skeleton,
Saguaro National
Park, Arizona

Photography books by John Annerino

CANYON COUNTRY:
A Photographic Journey

GRAND CANYON WILD:
A Photographic Journey

ROUGHSTOCK:
The Toughest Events in Rodeo

APACHE:
The Sacred Path to Womanhood

PEOPLE OF LEGEND:
Native Americans of the Southwest

THE WILD COUNTRY OF MEXICO:
La tierra salvaje de México

CANYONS OF THE SOUTHWEST

HIGH RISK PHOTOGRAPHY:
The Adventure Behind the Image

Also by the author

RUNNING WILD:
An Extraordinary Adventure of the Human Spirit

DEAD IN THEIR TRACKS:
Crossing America's Desert Borderlands

There was no record but memory and it became tradition
and then legend and then religion.
So long ago that they did not know themselves how long,
their ancestors, the ancient people, moved.
They went with the weather. Seasons, generations, centuries went by
as each brought discovery of places farther toward morning.

—Paul Horgan, *Great River*

Acknowledgments

MANY COMPANIONS ACCOMPANIED ME ON MY JOURNEYS THROUGH America's Outback over the years. Several stand out on the pages of this book; most remain behind these scenes. I'd like to thank Jason Lohman, for climbing Picacho del Diablo; Ernesto Molino and Louise Teal, and Neil Carmony and Dave Brown, for our voyages across the Channel of Little Hell to Tiburon Island; Jon Young, for walking the walk—and watching my back— in the borderlands; Jim Hills, for initiating me with the Seri; Bill Crawley, for showing me his world in Monument Valley; Cilla McClung, for canoeing the Rio Grande/Río Bravo del Norte through the Big Bend frontier; Bruce Lohman and Dave Roberson, for trekking the Camino del Diablo; Suzanne Jordan, for teaching me how to paddle the Grand Canyon of the Colorado River and Rob Elliott, for making sure I rowed my way back home; Tony Ebarb and Theresa Ebarb, for reasons that need no explaining; Bill Broyles, for sharing his secret knowledge of water; and Juan Váldez, for staying alive. I thank my brave wife, Alejandrina, and our dear sons for all the adventures and journeys we shared in between. I am indebted to my mentor, retired *Life* picture editor Melvin L. Scott, who first discovered the seeds to this book more than a decade ago, and I am especially grateful to Wendover Brown, Julie Taff, and Susan Heist at Browntrout, for publishing my first calendar *Desert Light* and those that followed. I laud the talents of Jennifer Thompson, Fred Lee, Dale Evva Gelfand, Deb Goodman, Susan McClellan, Jacques Chazaud, David Corey, Kermit Hummel, and Bill Rusin for bringing this volume to you. Thank you.

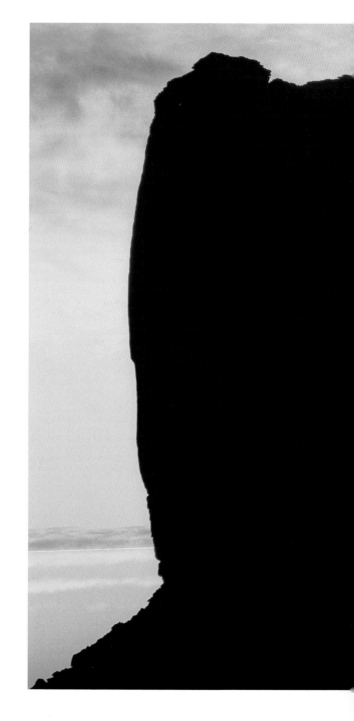

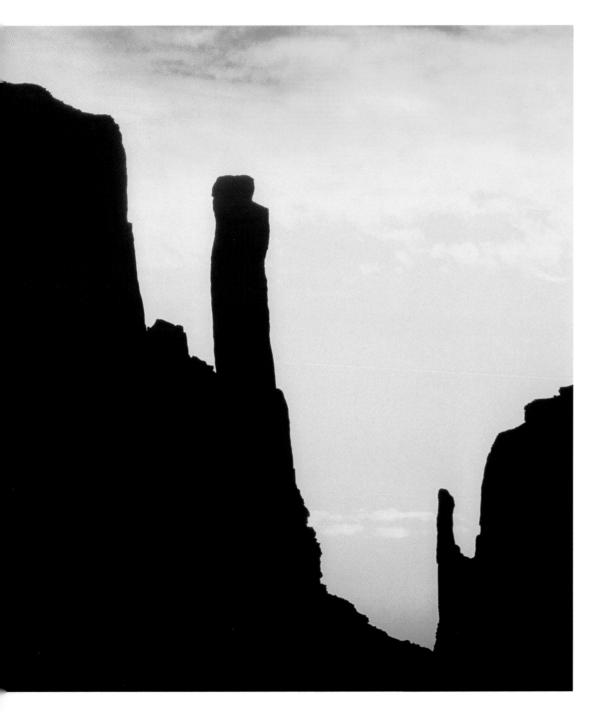

Contents

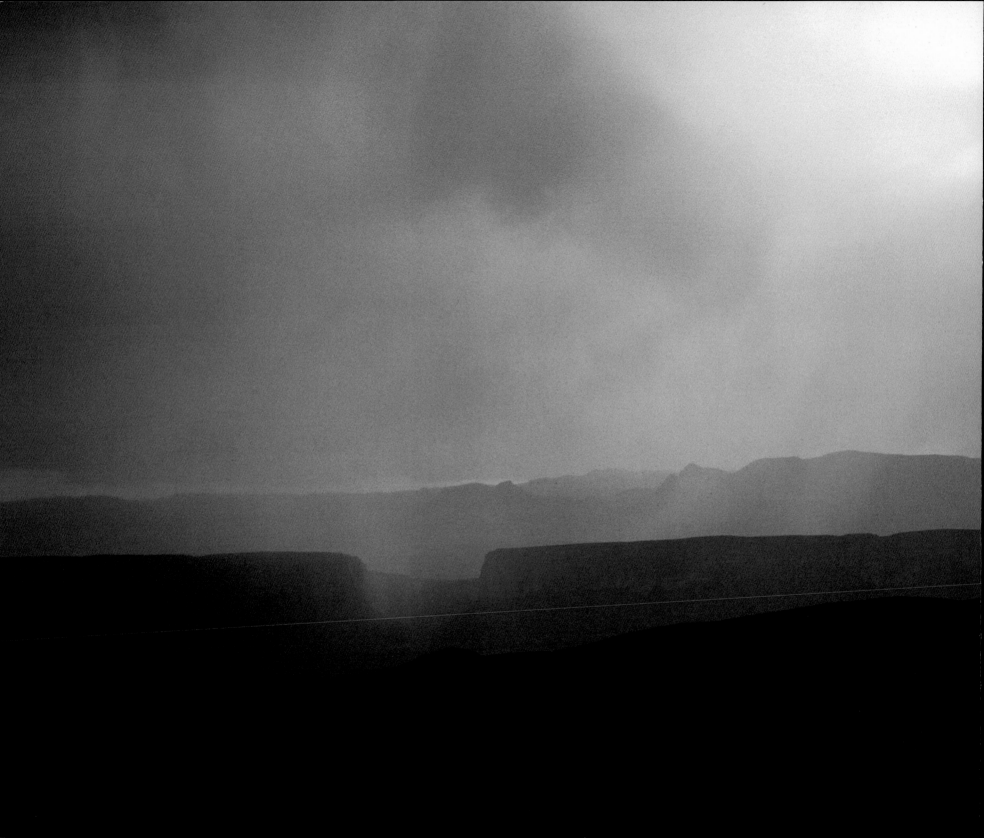

~ *Despoblado* ~

Emptiness. There was nothing down there on the earth—
no towns, no light, no signs of civilization at all. Barren
mountains rose duskily from the desert floor; isolated
mesas and buttes broke the wind-haunted distance. . . .
[Flying] nine miles a minute, that was a lot of
uninhabited distance in a crowded century.

—Marc Reisner, *Cadillac Desert*

THERE WAS NOTHING DOWN HERE ON EARTH. There were no towns for miles and miles in any direction. There were no lights shimmering across the sea of black desert. There were no signs of civilization except for a weather-beaten wooden plank painted in Spanish: CAÑÓN DEL DIABLO—Canyon of the Devil. That's what had lured me back to these barren mountains, which pierced the heavens from the desert floor. Cañón del Diablo was the gateway into the heart of the Big Empty, the most rugged, remote, and sublime corner

of the Great Southwest I'd ever seen. No one has lived here for centuries. The handful of people who've visited this fortress of stone in recent times had tempted fate and good fortune by climbing two vertical miles up from the burning salt pan of the San Felipe Desert to stand on the 10,154-foot summit aerie of Picacho del Diablo (Peak of the Devil). Except for heavily armed smugglers who offload airborne contraband on Playa del Diablo, few others had reason to venture across the hard-rock spine of the Sierra San Pedro Mártir, the "backbone of Baja." In his book *The Hidden West*, author Rob Schultheis wrote of similar territory: "It was hard country: nothing nice or comfortable about it. It was only gorgeous."

My quest had been simple. I wanted to bivouac on the summit of Baja's highest mountain to photograph the immense vista from its loftiest perch. Most photographs I'd seen depicted the sierra's majestic skyline profile from below. Few were the handiwork of expedition, adventure, or landscape photographers who crossed over from the safe haven of their car camps to explore the mountain's daunting ramparts. That came with calculated risk.

A month earlier I had turned back from my summit approach after a crushing boulder rolled over my right leg, pinning it against a slab of rock. Watching blood trickle into the cold, clear canyon stream, I levered the stone off my leg and spent a day and a half limping and boulder hopping down Cañón del Diablo back to my truck.

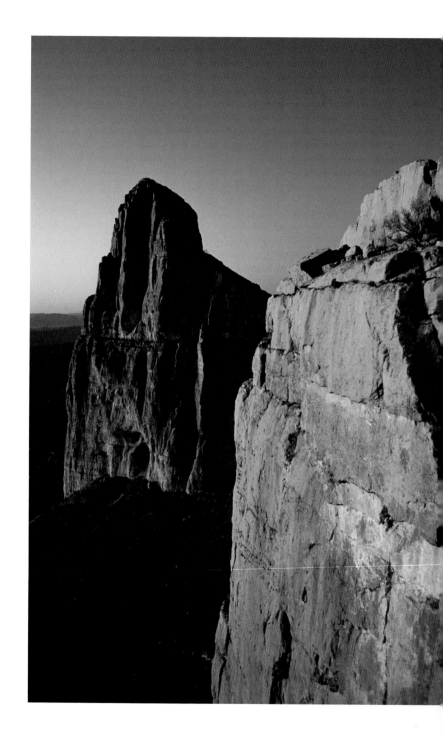

But I would be coming back. I was determined to get the summit photographs, and I was eager to survey the great sweep of desert on both sides of the U.S./Mexico border that has been called America's Outback. To do that, I reentered what California highway maps had written off as a blank spot, reminiscent of medieval cartographers who pointed to the uncharted regions on their parchments and declared, "Here be the dragons."

They weren't far off.

The white light was blinding. The stones were hot to touch. And the sweat stung my eyes, fogging my sunglasses. Granite teeth and knife-edged *cuchillos* (ridges) soared thousands of feet above me and my companion. They gnawed and slashed at powder blue skies as we toiled through narrow chasms choked with course white boulders that scraped my shins raw and wore the prints off my fingertips. We had struggled through a modern no-man's land that was the domain of *borrego cimarón* (bighorn sheep) and cougars that stealthily preyed on the ledges above. We had entered the impossibly rugged, stark, and beautiful ground of Native people who were driven to extinction by disease-carrying Black Robes, Jesuit missionary explorers, who'd journeyed eight hundred miles across the forlorn reaches of the Baja Peninsula to "save" them. How the Kiliwa, Nakipa, Akawa'ala, and Juigrepa survived in a labyrinth of hanging canyons that *gambusinos* (prospectors) cursed after the devil when they gave up

PREVIOUS SPREAD:

Las Aguas
(summer rain),
Sierra Hechiceros,
Chihuahua, Mexico.
Chihuahuan Desert.

◀ Sierra del Carmen,
Coahuila, Mexico.
Chihuahuan,
Desert.

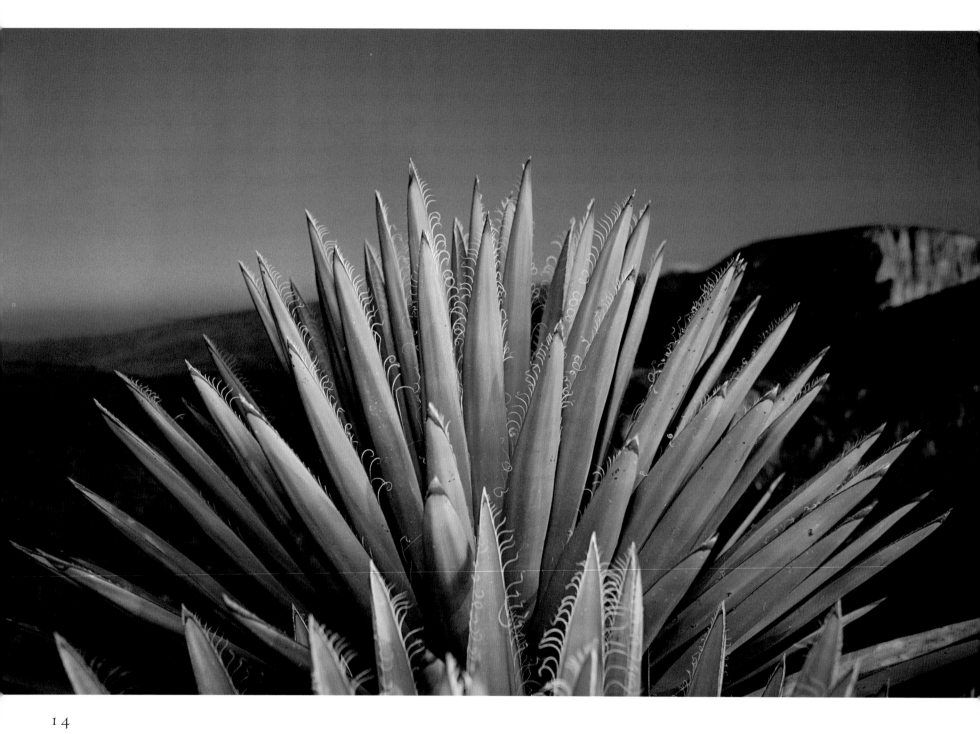

their quest for gold is impossible to say without speculating. But the demise of the region's indigenous people was not romantic, nor was it colorful. It was a tragic fact of history that characterizes much of America's Outback today. Yet the ancestral lands remain—and they're nearly always alluring, frequently abandoned, largely forgotten.

Difficult as it is to imagine in this crowded century, there are many such places throughout the Great Southwest, and many are off the radar. Most are lost to contemporary memory, dreams, imagination, literature, music, and photography. Others, like Picacho del Diablo, are literally *off* the radar. What struck me most about Cañón del Diablo was the silence. It was unnerving.

Venture into the most remote tract of Mexico's storied Sierra Madre—where "Stone Age" Tarahumara still live—break a leg, and chances are someone will hear you scream. Break a leg in Cañón del Diablo, and nobody will hear you scream, whimper, and die, except the coyotes, buzzards, and sidewinders. As we had climbed up hanging ramps that snaked through soaring cliffs of Precambrian granite thousands of feet to the summit of Picacho del Diablo, there was absolute silence—except, of course, for the crunching of our footsteps and heavy breathing in the cool, thin air. The nearest highway, Mexico's Highway 2, was 130 miles north. The distant nighttime rumble of trains, often heard even in the most isolated pockets of

Agaves, Sierra del Carmen, Coahuila, Mexico. Chihuahuan Desert.

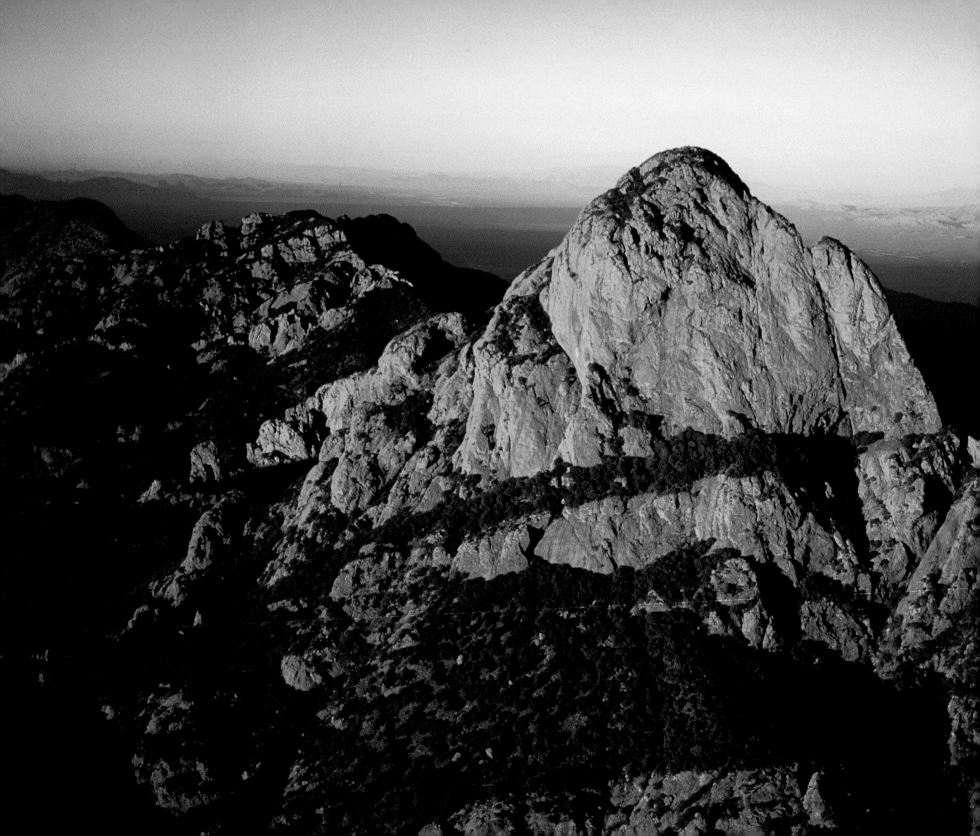

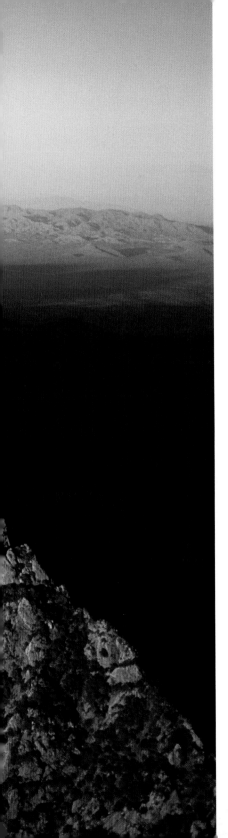

the American West and Old Mexico, was absent. Even commercial airliners, a common sight and sound elsewhere in the forsaken expanses of the Big Bend frontier, Western Grand Canyon, and Escalante–Grand Staircase, avoided this Bermuda Triangle of stone. Had cell phones existed at the time, we were so far off the grid that they would have been useless.

At some imperceptible point in our two-day ascent, we had crossed over into this void. Conscious thought surrendered to instinct. In 1539 the Franciscan explorer Fray Marcos de Niza called the fifteen-day-long *jornada* (journey) to reach the fabled Seven Cities of Gold—in what would become New Mexico—a *despoblado* (uninhabited land). Nearly five hundred years later that impression has not changed. Signs posted in Mexico now warn of crossing the Camino del Diablo region of Arizona's Organ Pipe Cactus National Monument because it's a *zona despoblada* (uninhabited zone). A ruthless conquistador who massacred the Zuni at Hawikuh, Francisco Vásquez de Coronado, precipitated a practice used by other sixteenth-century Spaniards who described their own *entradas* (entries) into the Great Southwest as crossing *Terra Incógnita*—Unknown Country. Euro-American explorers and mountain men later called such tracts of land "wilderness."

Their descendants still cling to the notion that Oglala Sioux Chief Luther Standing Bear eloquently defied: "We did not think of

◁ Baboquivari
Mountains,
Arizona. Sonoran
Desert.

17

the great open plains, the beautiful rolling hills, and the winding streams with tangled growth as 'wild.' Only to the white man was nature a 'wilderness,' and only to him was the land 'infested' with 'wild' animals and 'savage' people." Surprisingly, it remains just that for most—a wilderness. America's Outback is different. It hasn't been coiffed by hand-forged trails, fluorescent signs, boot prints of backcountry ranger patrols, and paved roads leading to scenic vistas. The land remains largely as it was when it was still inhabited by Native Americans and indigenous people. It is the back of beyond, it is empty ground, it is America *Out*back.

Throughout his literary career, Edward Abbey passionately invoked Americans to sit up and take notice of this sort of country, and he summed up the mysterious power the desert held over him when he wrote in *Cactus Country*: "There's something about the desert." Indeed there is. And it's different for everyone. If legend, desolation, and haunting beauty first lured me into the tortured ground of the Superstition Mountains in my teens, I was later rewarded when I met locals and indigenous people still living elsewhere "in the middle of nowhere." But there was another, more primal, force that kept bringing me back to the desert: the light. There's nothing quite like it, not the smell of greasewood after summer rains, nor the sight of golden poppies carpeting the *bajadas* (slopes) in the spring, the sound of floodwater roaring down a dry

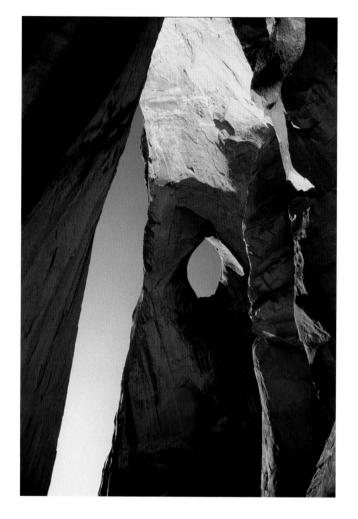

▲ **Suns Eye, Mystery Valley, Arizona. Painted Desert.**

▶ **Isla Tiburón, Sonora, Mexico. Sonoran Desert.**

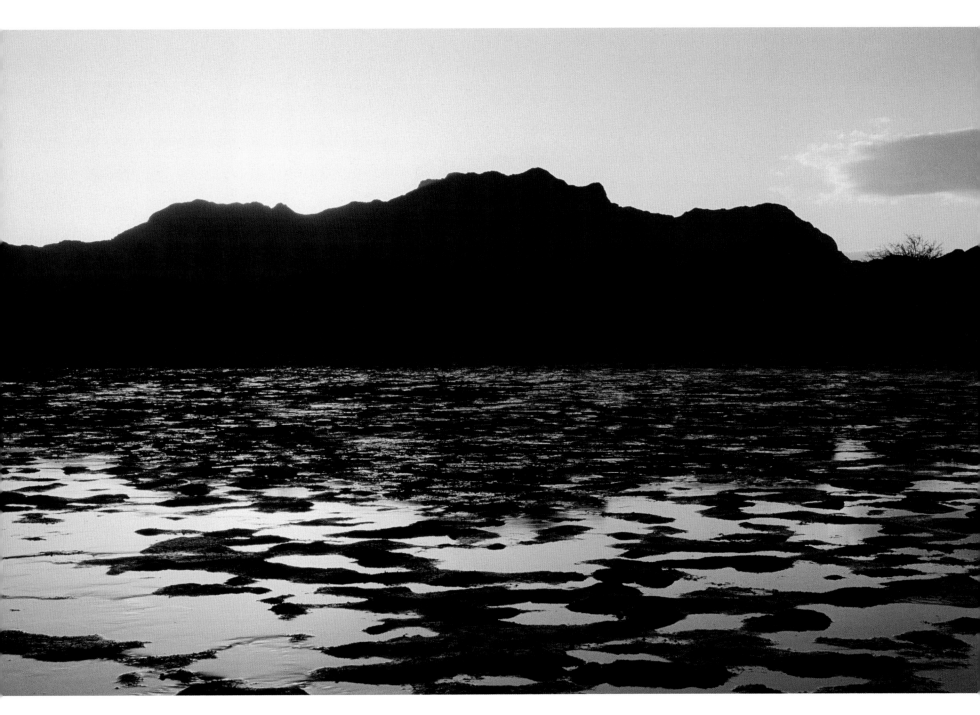

arroyo, or the crackling sparks of a mesquite fire floating into the starry heavens.

I was a moth going to the flame, sometimes pushing the envelope to glimpse and photograph those fleeting moments of desert light that seemed to buzz with electricity. That's what had pushed me all the way to the summit of Picacho del Diablo as I coaxed my companion on. I wanted to see the fiery sun set in all its glory, fade to the purple hues of twilight, and turn to the opaline haze of darkness. When we could climb no further, we nestled our packs in a summit crevice, warded off the chill with jackets, and surveyed the great desert at our feet.

The images that follow reflect my journeys across the *despoblado* that fanned out from the base of Picacho del Diablo across the midnight blue-horizon of Baja California Norte into the no-man's land of the Chihuahuan Desert, the mysterious lands of the Sonoran Desert, and the haunted land of the Painted Desert. They highlight the luminous moments I had the good fortune to witness, companions who braved the rigors and shared the rewards, and a handful of spirited individuals, among many I met, who still live with few regrets in the middle of nowhere.

▶ Jason Lohman at summit bivouac, Picacho del Diablo, Baja California Norte, Mexico.

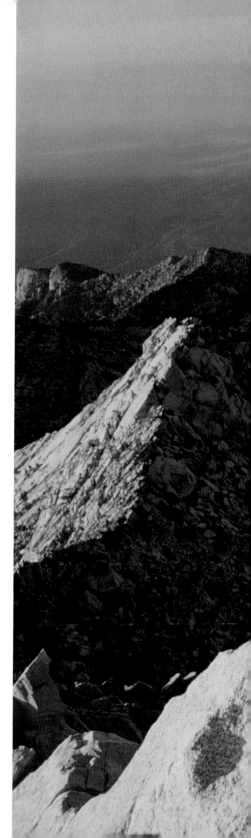

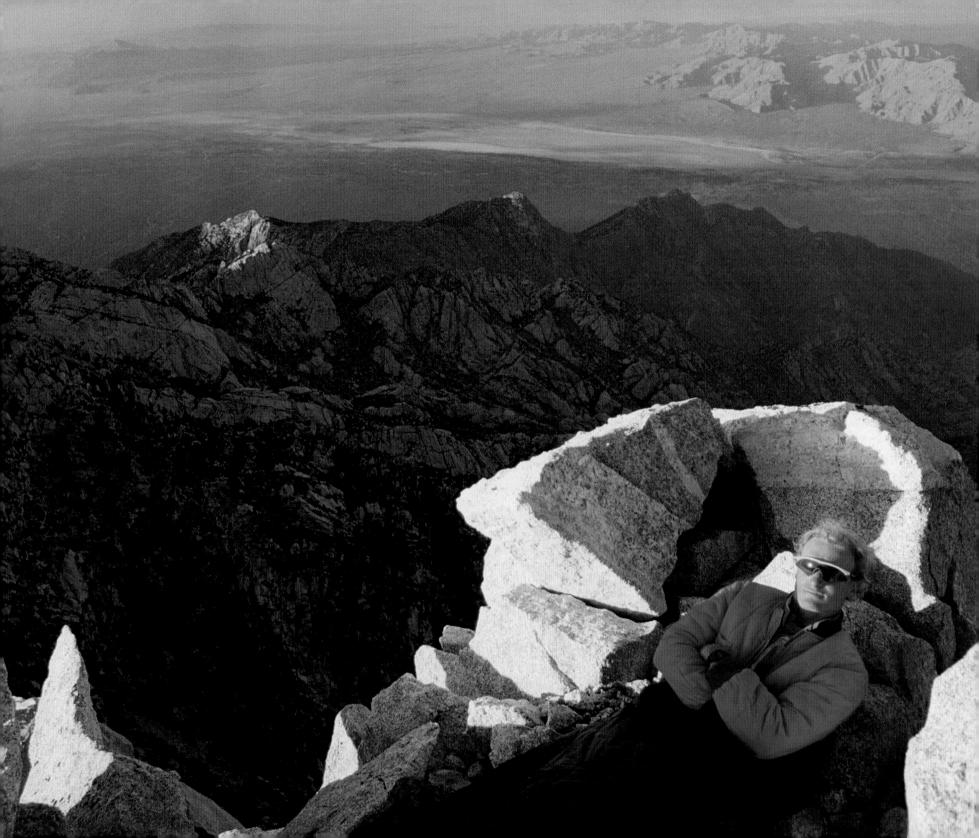

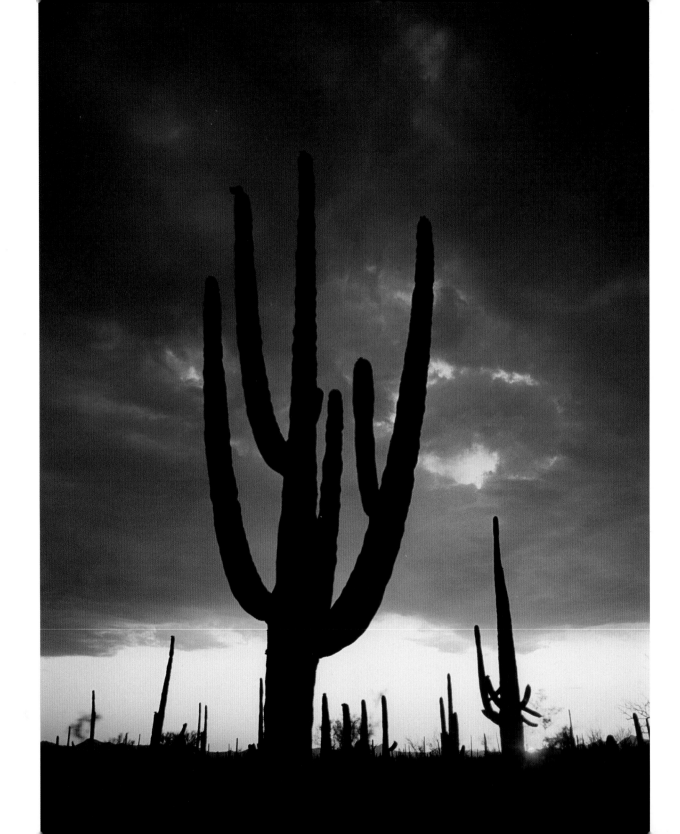

▶ Sunset, Saguaro
National Park,
Arizona. Sonoran
Desert.

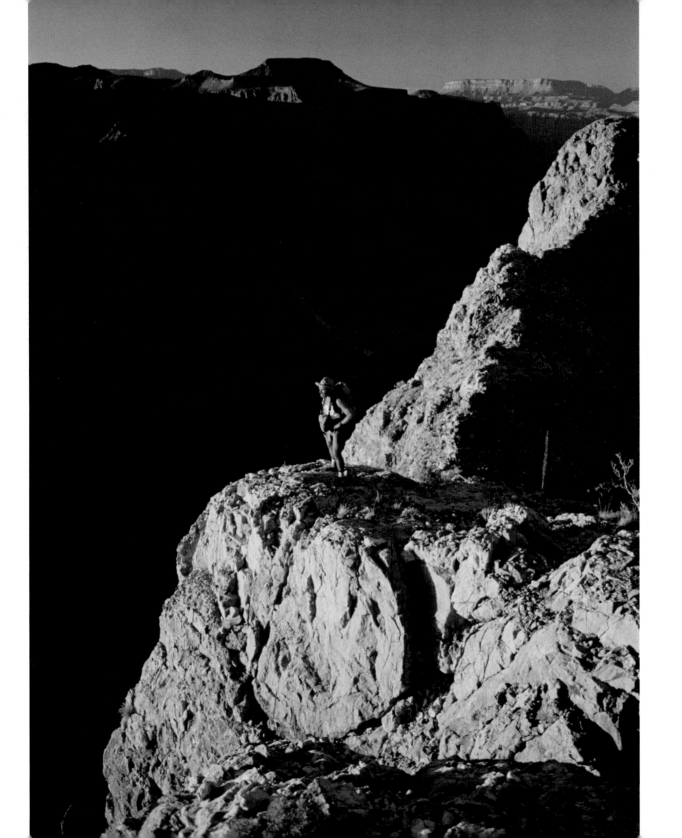

◄ Dave Ganci,
Diamond Peak,
Western Grand
Canyon, Arizona.
Mojave Desert.

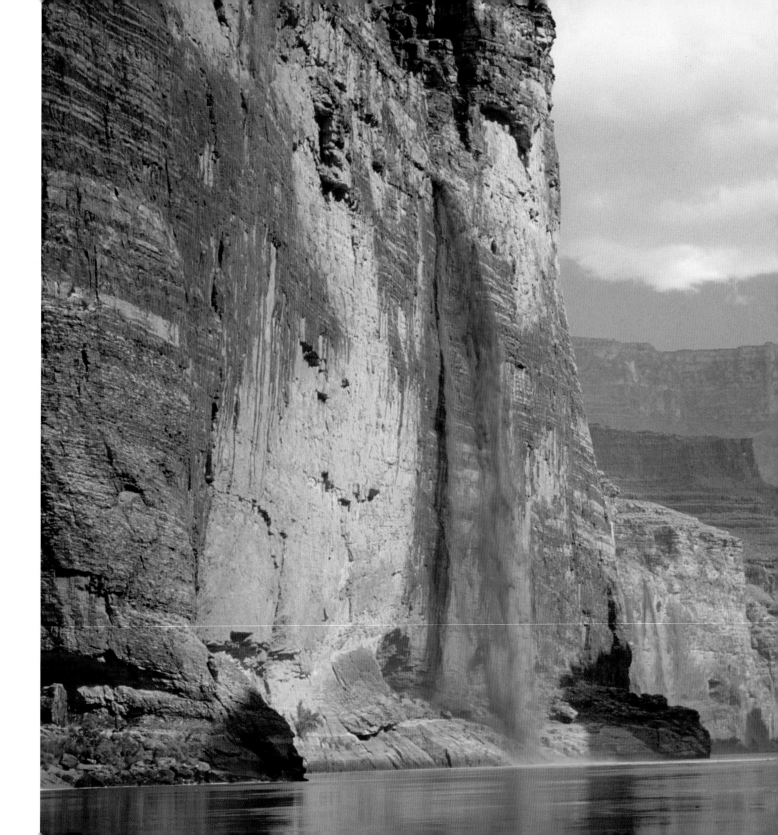

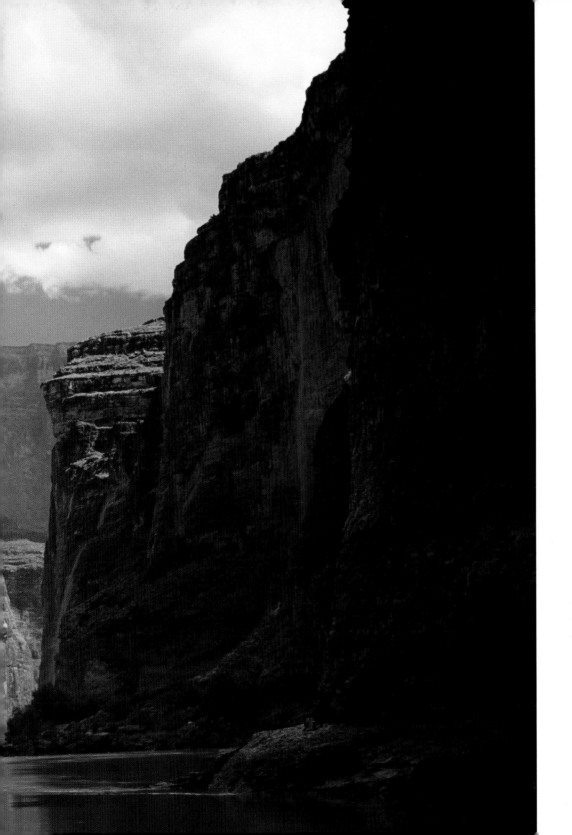

◀ Monsoon cascades,
Colorado River,
Marble Canyon,
Arizona. Painted
Desert.

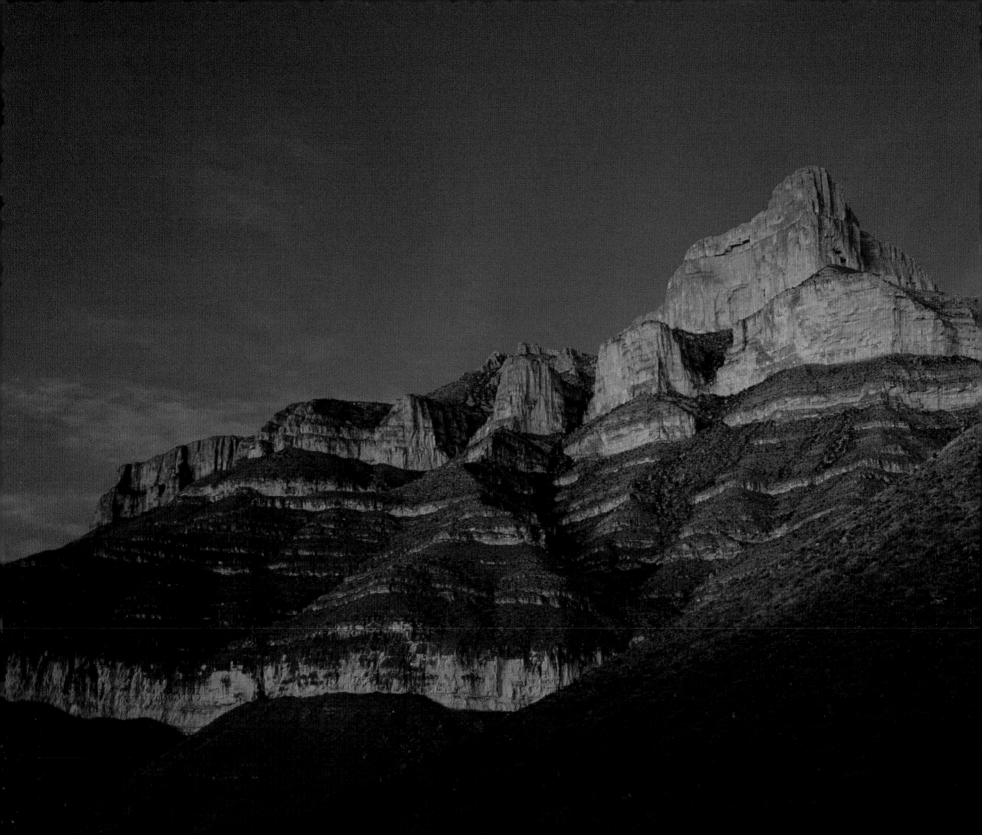

~ No-Man's Land ~

At the time it was a veritable "no-man's land,"
and few people had ventured into its deep, rugged,
and almost impassable canyons.

—Frank Collison, *Life in the Saddle* (1882)

IT STILL IS A "VERITABLE 'NO-MAN'S LAND.'" I DISCOVERED that not long after I crested the sun-scorched plateau of the Sierra el Terminal and traced the old burro trail through gangly stands of ocotillo into a deep, rugged, and almost impassable canyon called El Socavón a half day east of Boquillas del Carmen. Forged by two hundred people struggling for survival in the cruel and miraculous landscape of the Chihuahuan Desert, Boquillas del Carmen was the last outpost in the Big Bend frontier of West Texas and Chihuahua and Coahuila, Mexico.

I had prepared myself for the desolation that lay beyond its handmade adobe dwellings and wooden corrals; I had anticipated the austere beauty that offered scant forage for its cattle and goats; and I

had steeled myself for the fact that once I walked down the dirt road out of town, I would be entering alone one of the most remote tracts of the Great Southwest this side of Picacho del Diablo. But nothing brought the reality of my dream into sharper focus than the deserted wax makers' camp I reached near the mouth of El Socavón (The Tunnel). Over a short pull of stomach-burning *sotol* at a hole-in-the-wall cantina the evening before, friendly locals told me the *cereros* (wax makers) would point the way to the summit of the Sierra del Carmen. *"Sí, en el campo de los cereros. Allá."* (Yes, in the wax makers' camp. Over there.) To my surprise, the *cereros* had melted into the landscape before I arrived. Even these hardy desert dwellers had fled this hole on the map for a few days of lantern-lit civilization in the maw of the 175,000-square-mile Chihuahuan Desert.

Stretching south from the hypnotic, shape-shifting sweep of White Sands, New Mexico, to *las quebradas* (broken country) of Durango and Zacatecas, Mexico, the Sierra del Carmen and Big Bend National Park form what is arguably the most beautiful and diverse corner of North America's biggest desert. Except for the Sonoran Desert's Desierto de Áltar (Altar Desert), which hosts the largest sand sea on the continent, the Big Bend frontier was the most isolated, least inhabited, and seldom-visited terrain I knew of.

I carefully made my way into this no-man's land, unsure of

PREVIOUS SPREAD:
Twilight, Sierra del Carmen, Coahuila, Mexico.

► **Rock Nettle, Big Bend, Texas.**

what lay beyond the *cereros'* camp except fear, uncertainty, and what looked like impenetrable cliffs rimming the headwall of El Socavón. My goal was to cross the desert steppes from Boquillas del Carmen on foot and climb to the summit of the Sierra del Carmen to photograph the frontier from above. The postcard backdrop for Big Bend National Park, the Sierra del Carmen links the Sierra Madre Oriental (Eastern Sierra Madre) of Mexico with the Rocky Mountains of the United States. But the Sierra del Carmen wasn't located in the legendary borderlands claimed by the Lone Star state. It was located in another country. That's what a park naturalist told me when I inquired about climbing the Sierra del Carmen at the Big Bend visitors center several days earlier. "Don't you know that's another country over there," she said, scolding me for thinking such thoughts. I bit my tongue. Recognized as the most remote national park in the United States, Big Bend lay virtually in "another country." Bypassed by the transcontinental traffic of Interstate 10 some 150 miles north, the 1,250-square-mile expanse of Big Bend is bordered on the southeast by the frontier of Coahuila and on the southwest by the frontier of Chihuahua.

I'd come to understand the regional setting of the U.S./ Mexico border near the end of ten-day canoe trip down the Rio Grande/Río Bravo del Norte a few years earlier. Born in the icy snowfields of Colorado's 14,309-foot-high San Juan Mountains, the

Rio Grande/Río Bravo del Norte empties into the Gulf of Mexico
1,896 miles from its source. Joined by a common biodiversity that
includes migrating species of Mexican black bear, Sierra del Carmen
whitetail deer, and mountain lions, Big Bend's 7,825-foot Chisos
Mountains lay on one side of the river and the 8,412-foot Sierra del
Carmen lay on the other. As I paddled through the frontier's deep
river canyons of Mariscal, Santa Elena, and Boquillas del Carmen,
I noticed that the volcanic crags of the Chisos Mountains shared
the same picturesque horizon with the soaring limestone reefs of the
Sierra del Carmen. Yet, as we floated beneath sheer walls that cleaved
Boquillas del Carmen, I promised myself I would climb the daunting
peak that loomed over the south side of the river, not the mountains
to the north. That was easier said than done.

The western flanks of Sierra del Carmen rose nearly seven
thousand feet from the floor of the Chihuahuan Desert at river's
edge. Steep talus slopes that clung to precipitous walls near the head
of El Socavón bristled with golden, bayonet-shaped leaves of the
sotól agave. Settlers called them "Spanish daggers" because one
careless slip and they could impale a man or a horse with a crippling
wound. I carefully threaded my way through the heavily guarded
terrain, but flint-edged boulders raked my ankles and knees, some-
times tripping me. The tall spindly arms of ocotillo were not good
crutches to grab hold of. Covered with rows of crucifixion-type

▶ **Sunset, Sierra del
Carmen, Coahuila,
Mexico.**

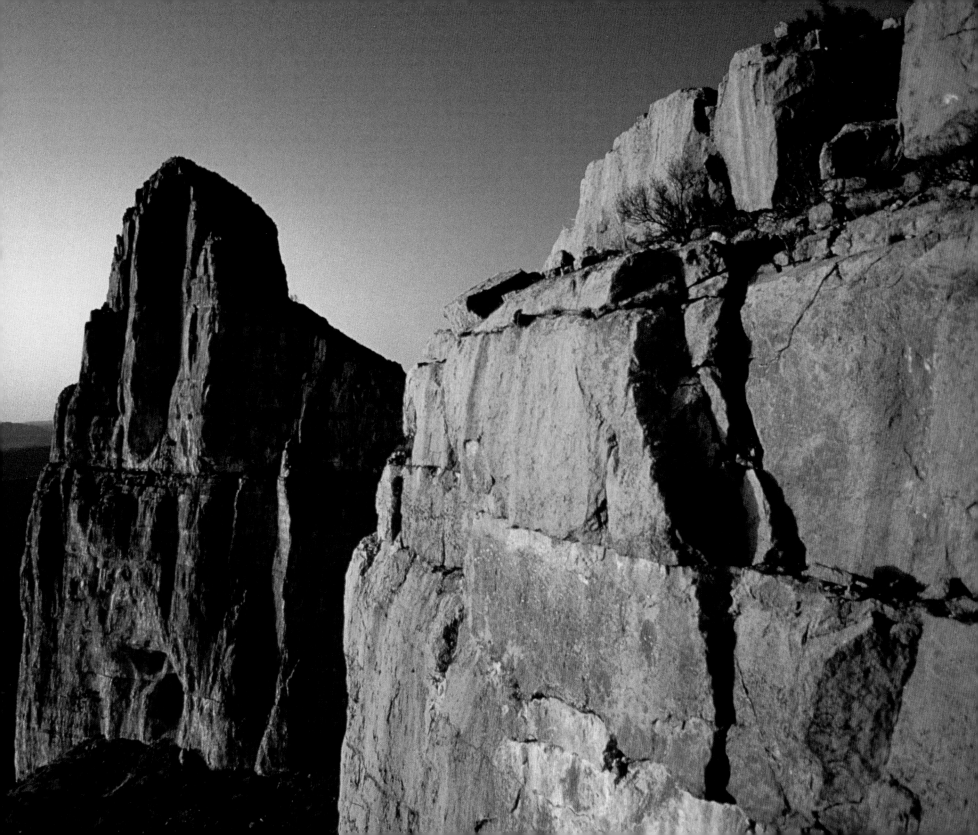

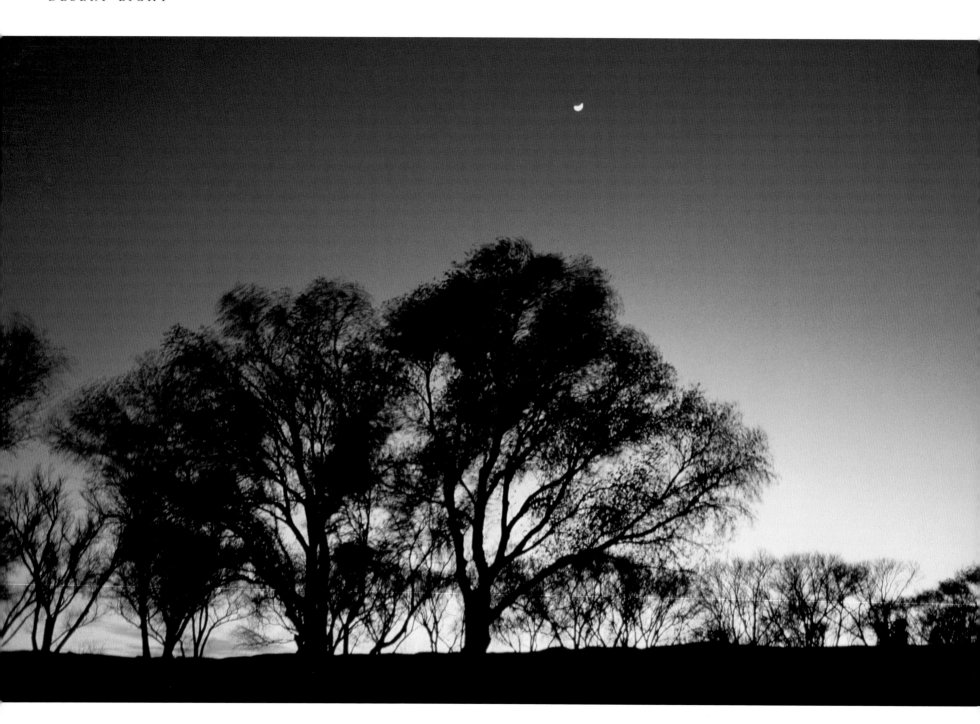

thorns that flogged the desert winds for easy prey, ocotillos earned the scorn of leather-faced vaqueros who, protected by thick rawhide leggings called chaps, named them *El Bastón del Diablo* (Devil's Walking Stick). Even without defenses that demanded blood with every faulty step, the mountain was a struggle. The solar heat of the winter sun baked the walls that soared above.

I pushed on. My thighs burned with each footstep as the narrow ledge slithered around the edge of the precipice and cliffed out at the foot of a sheer wall. Drenched with sweat, and bleeding from cuts, scratches, and punctures, I stopped and wiped the tears streaming down my sun-burned cheeks. Swaying in gusts of hot wind, I untied the bandana from my neck, doused it with water, and daubed the wounds on my arms and legs. It was getting late, and the sun would soon set. I could abandon this ascent and retreat back down El Socavón and camp near Agua Dulce (Sweet Water Spring). But I had enough water for another summit attempt. So I rolled out my sleeping bag across the ledge and bivouacked in a cozy depression of gravel and rock. Lying down on my sleeping bag, I felt the warm breeze wick the blood, sweat, and tears off my skin, coating it with a rime of pink salt. I closed my eyes and dozed off until thirst and cold awakened me to comet-streaked black skies. Sitting up, I took a long drink of water, and then pulled off my shoes and tied them to my pack, which I used as a pillow, so I

◄ Twilight, Rio Grande/Río Bravo del Norte, Big Bend, Texas and Coahuila, Mexico.

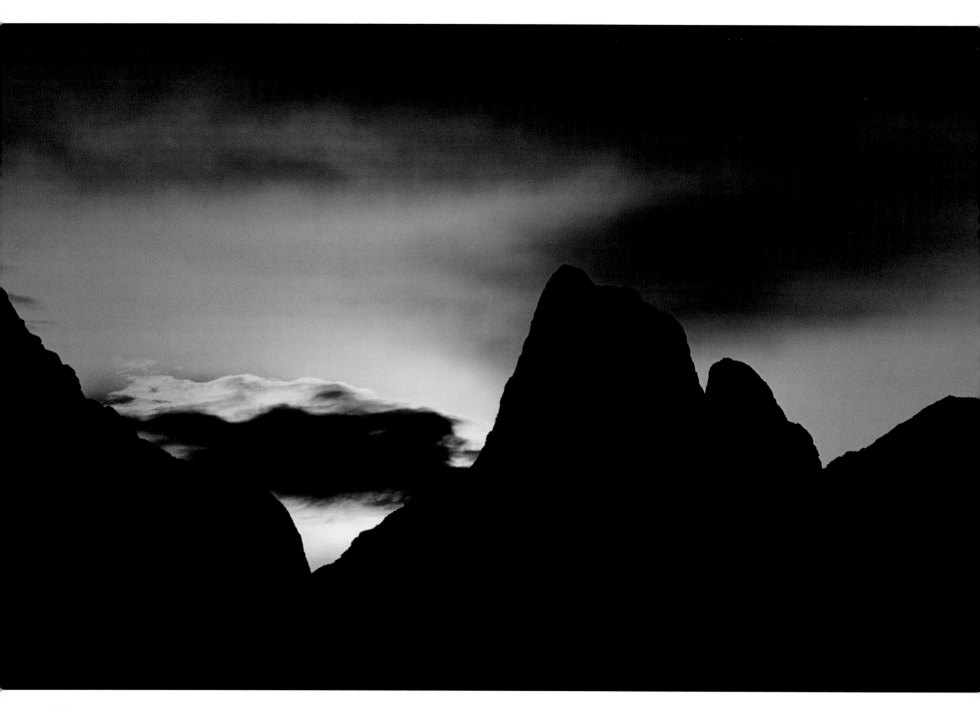

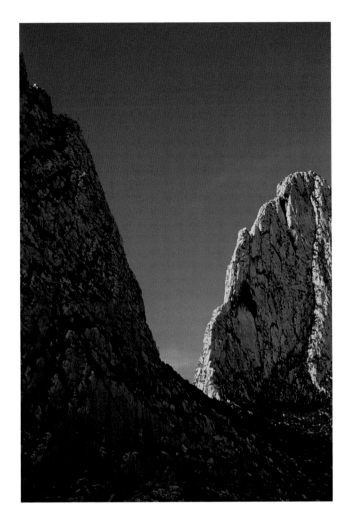

▲ Cañón de Huasteca,
Sierra Madre
Oriental, Nuevo
León, Mexico.

◄ Monsoon, Chisos
Mountains, Big
Bend, Texas.

wouldn't kick them over the edge of the cliff in the middle of the night. I was alone. But my fears had drained out of me, giving way to peace as I climbed into my sleeping bag, and my dreams wandered amongst the stars.

I awoke long after daybreak, stiff from dehydration and fatigue. I boiled some coffee on my stove and washed down breakfast of cold beans and tortillas with the sweet hot brew. It was a new day, and I was filled with hope and determination as I shouldered my pack and traversed the ledge back into the head of El Socavón.

The cliffs and terraces above were intimidating, but the terrain looked surprisingly similar to the Grand Canyon's Redwall Formation. Even with such a formidable barrier, I'd learned there were lines of weakness through the Redwall band. It was just a matter of following the right ledge system. The imposing walls of the Sierra del Carmen couldn't be much different from the Grand Canyon's.

To the north, I could see the Espinazo del Diablo (Devil's Spine), and I used the stony cockscomb as an orientation point as I traversed an upper-ledge system below the Sierra del Carmen's looming cliffs. I looked up and saw a steep chute that led to the summit ridge two thousand feet above. The sun was descending, and my water was dwindling. So I cached my pack and grappled toward the summit with my camera and tripod.

It was 4:00 PM sharp when I reached the barren, wind-swept

summit notch. At first glance there didn't appear to be a safe route to the summit of Pico del Carmen without a climbing rope. So I climbed a high point on the summit ridge a hundred yards distant. To the south, the Sierra del Carmen's golden ribbons of limestone ran toward the horizon of the distant Sierra Madre Oriental. To the north, Pico del Carmen, a stark shield of bronze in the setting sun, stood vanguard over the silver strand of the Río Grande/Río Bravo del Norte. It wound through the black canyons, red desert, and lavender glow of the Big Bend frontier. This no-man's land was once home to the Chisos, indigenous peoples massacred by sixteenth-century conquistadors. In vanquishing this resilient culture, the Spaniards created the very *despoblado* they'd cursed and feared.

I carefully made pictures on the brink of this world until the red sun fell into the dark horizon, the desert turned blue, and the walls of Sierra del Carmen glowed with incandescent light. I plunged into the notch and glissaded down the chute through rock, rubble, and dust until I reached my pack. I drank water. It was now dark, but there was still enough ambient light reflecting off the walls to feel my way along the hanging ledges into El Socavón and camp. I rolled out my bedroll on the canyon floor, soothed by the trickling sound of Agua Dulce.

I was content. I closed my eyes. And I slept like a dead man until songbirds awakened me at first light.

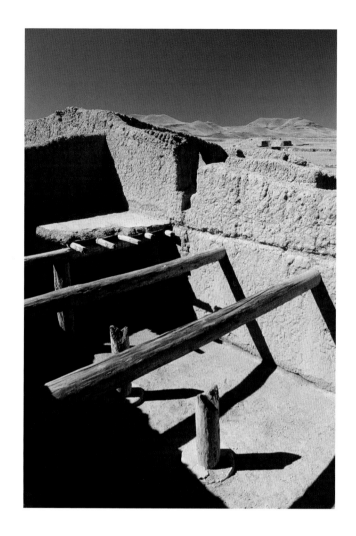

▲ Paquimé,
Chihuahua, Mexico.

▶ Paquimé,
Chihuahua, Mexico.

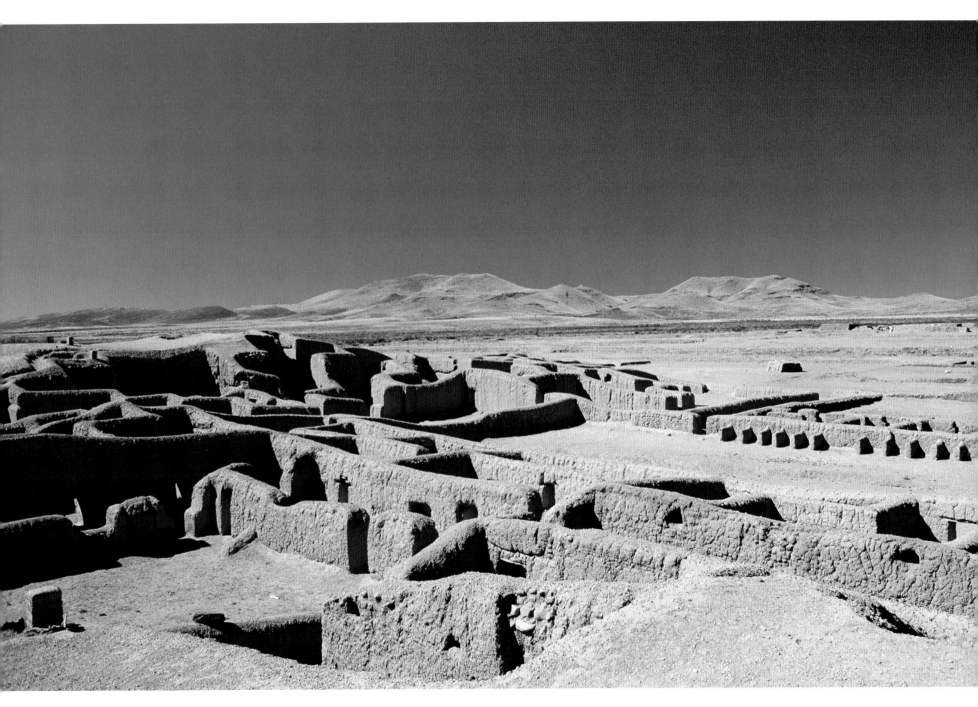

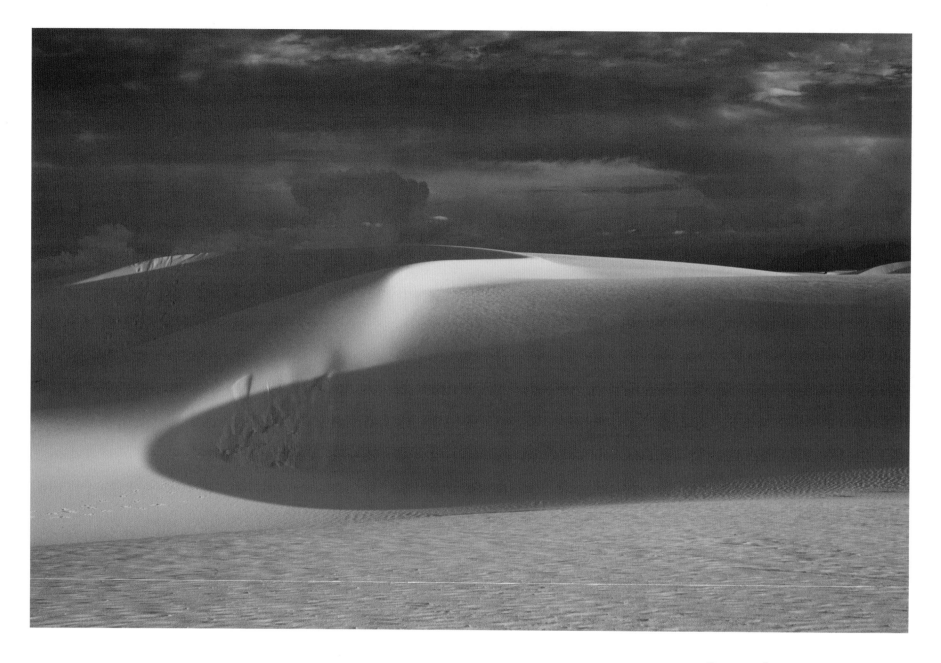

Gypsum dunes,
White Sands, New Mexico.

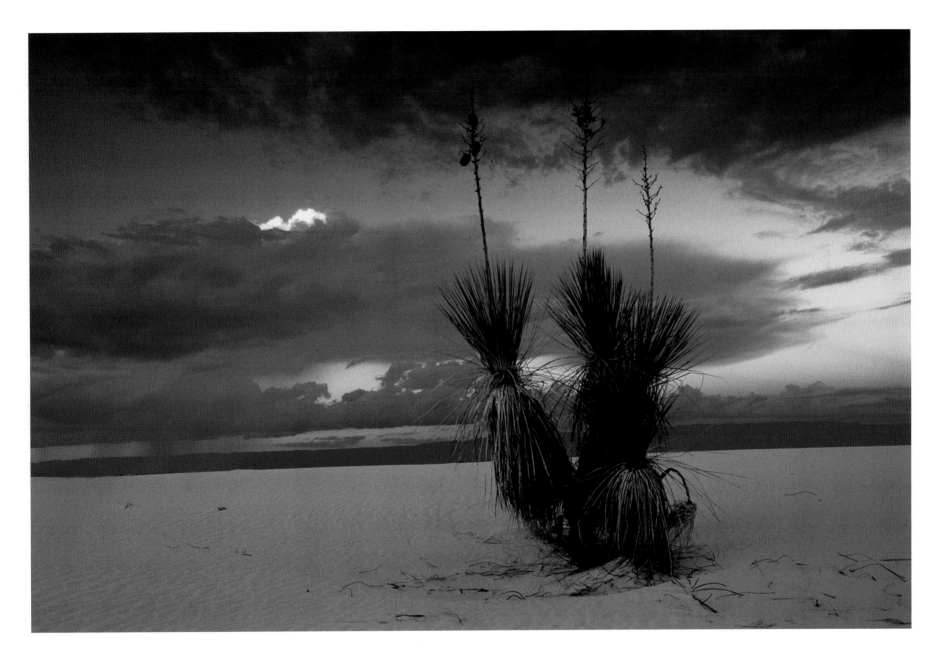

▲ Soaptree Yuccas,
White Sands, New Mexico.

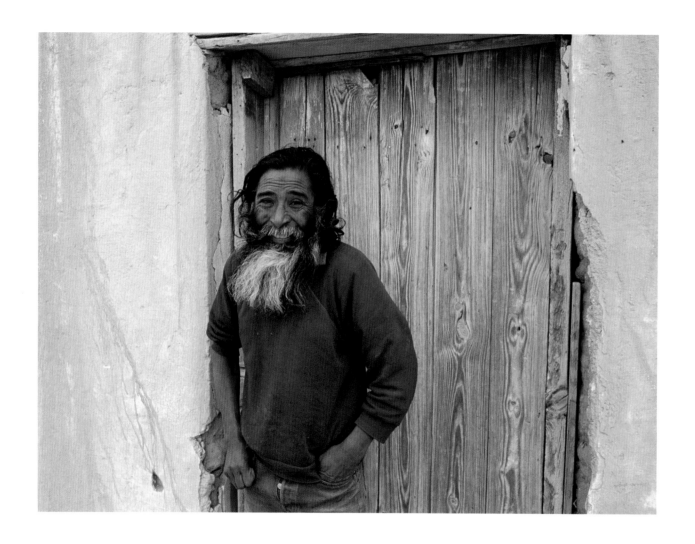

▲ Juan Váldez, ▶ Historic cemetery,
Boquillas del Carmen, Terlingua Abaja,
Coahuila, Mexico. Big Bend, Texas.

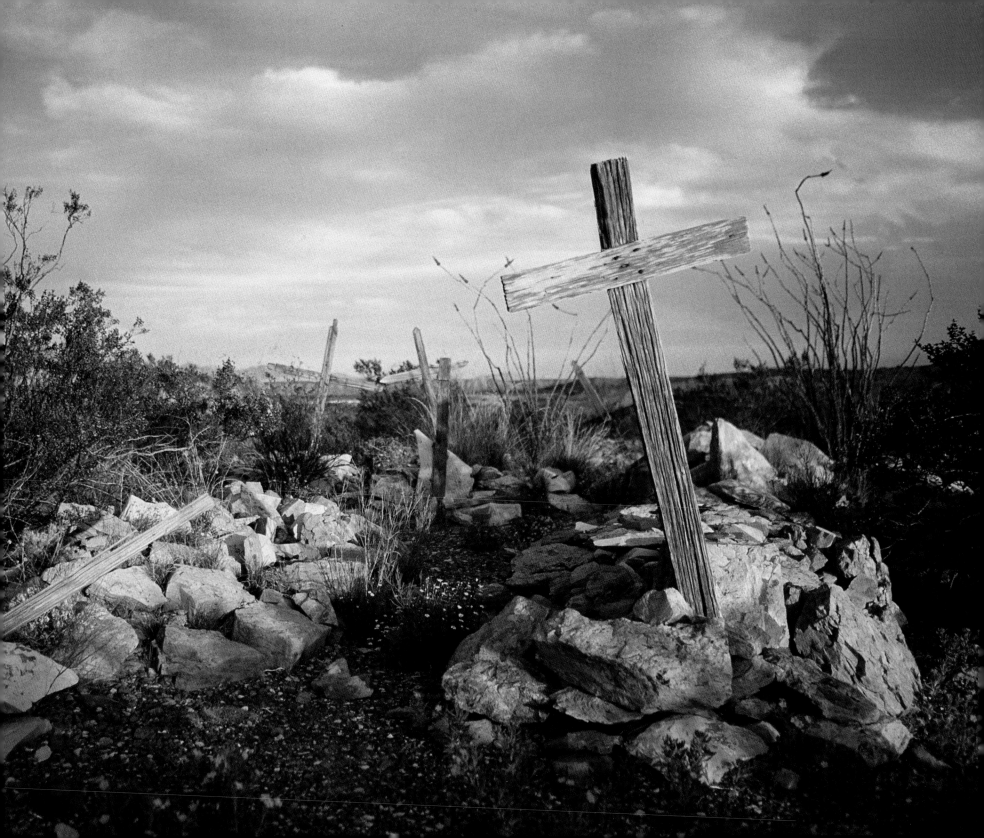

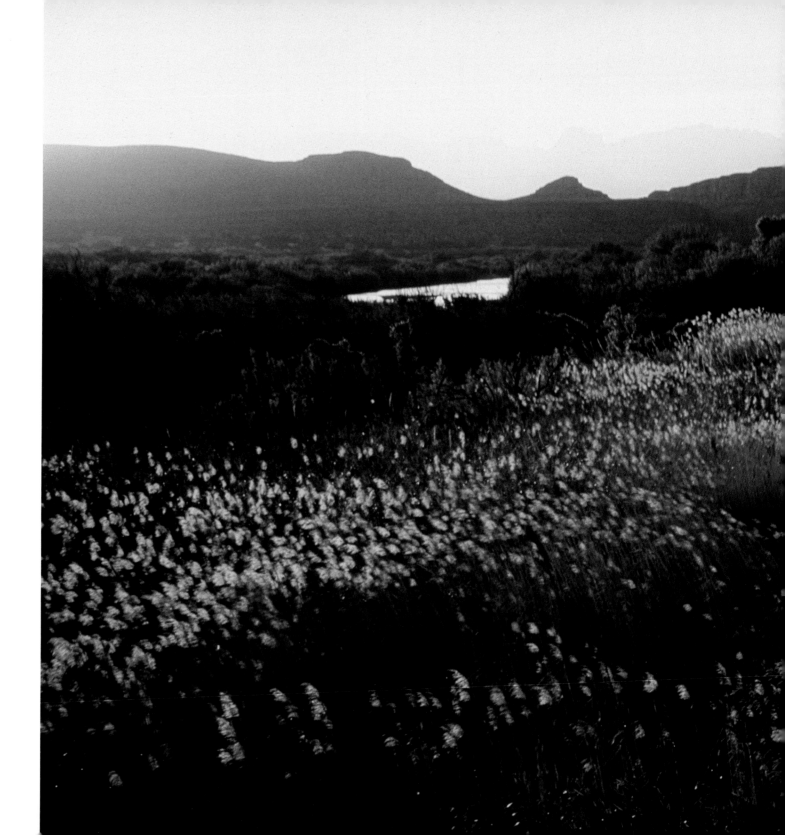

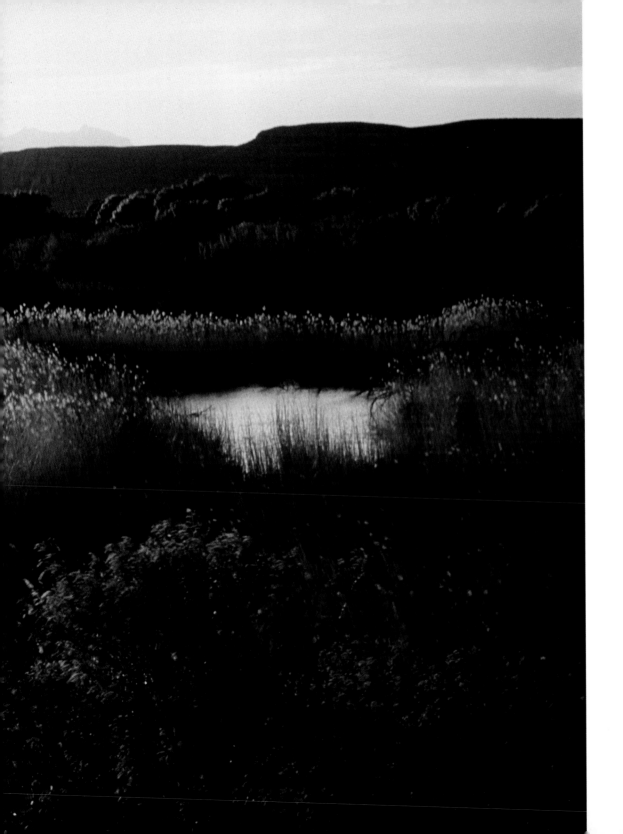

◄ Rio Grande,
Big Bend, Texas.

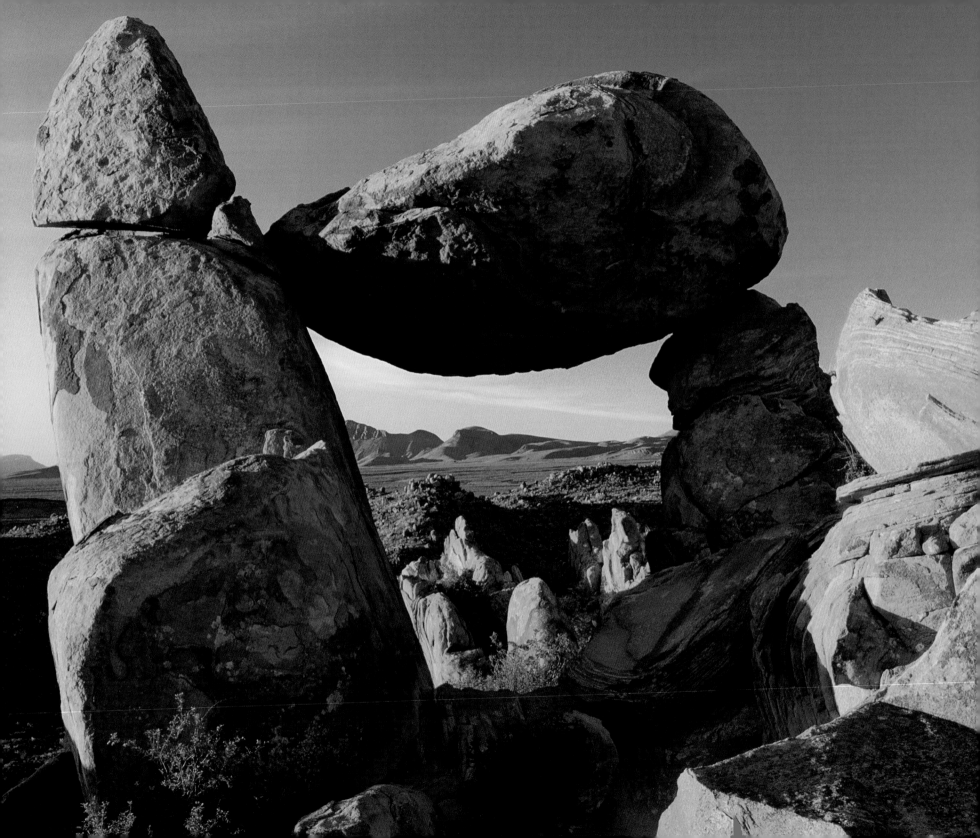

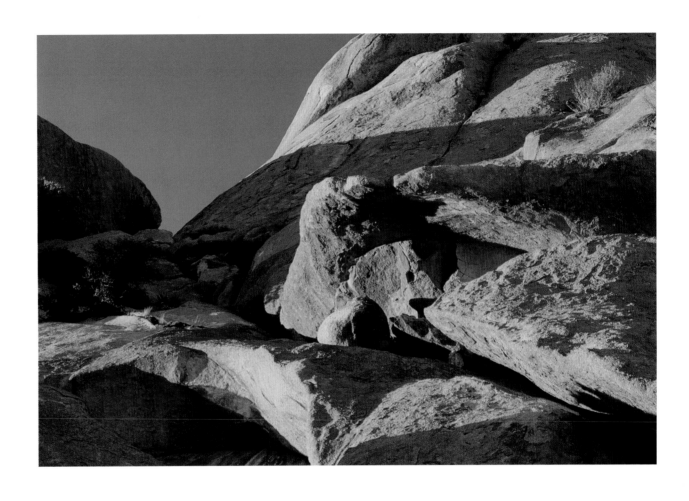

◀ Balanced Rock,
Grapevine Hills,
Big Bend, Texas.

▲ Cochise Stronghold,
Dragoon Mountains,
Arizona.

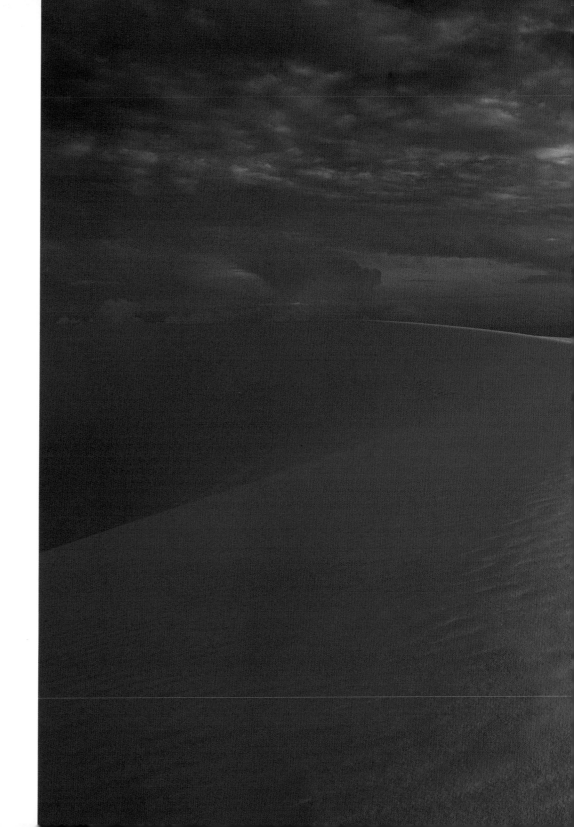

► Dreamscape,
White Sands,
New Mexico.

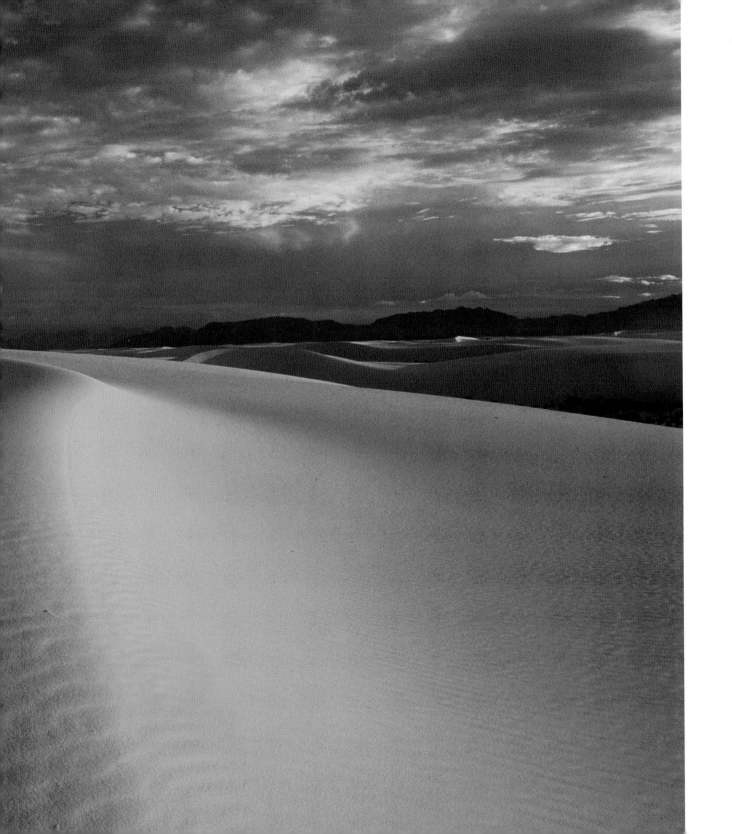

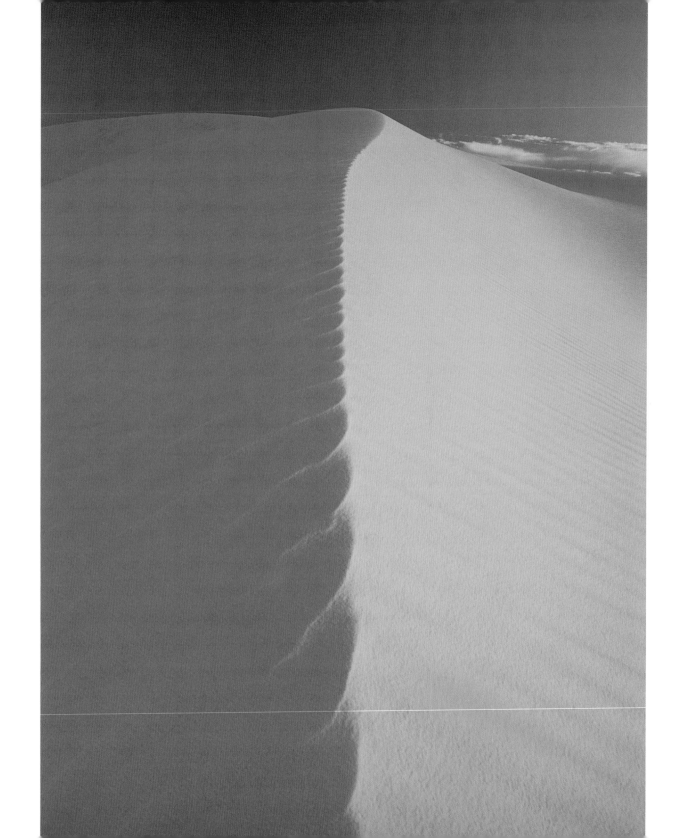

► Shape-shifting
dunes, White
Sands, New
Mexico.

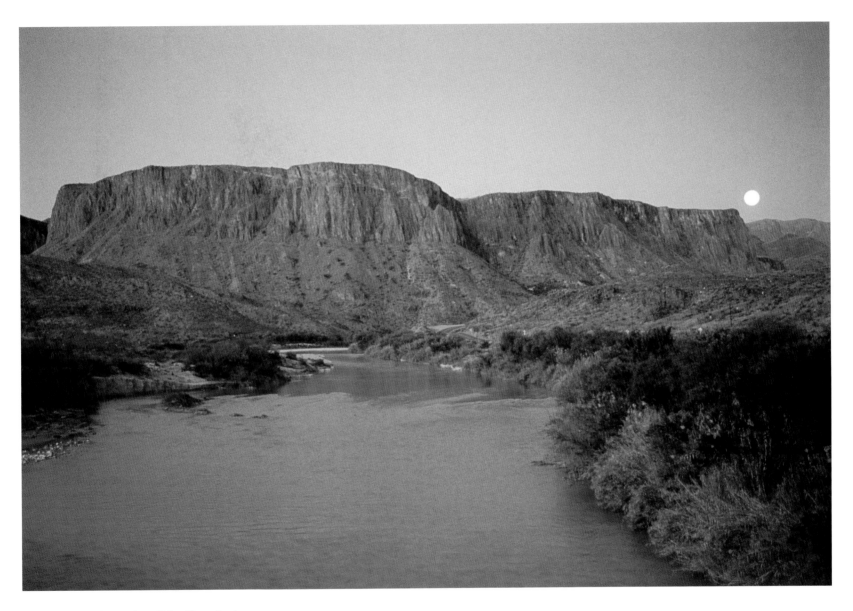

Moonrise, Rio Grande/
Río Bravo del Norte,
Texas and Chihuahua,
Mexico.

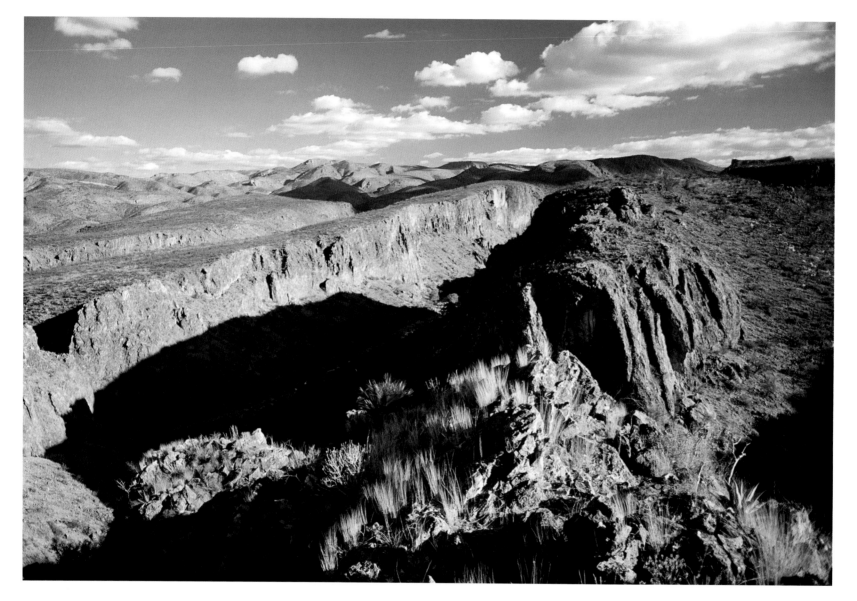

▲ Las Quebradas,
Río Nazas,
Durango, Mexico.

► Limestone reef,
Sierra del
Carmen, Coahuila,
Mexico.

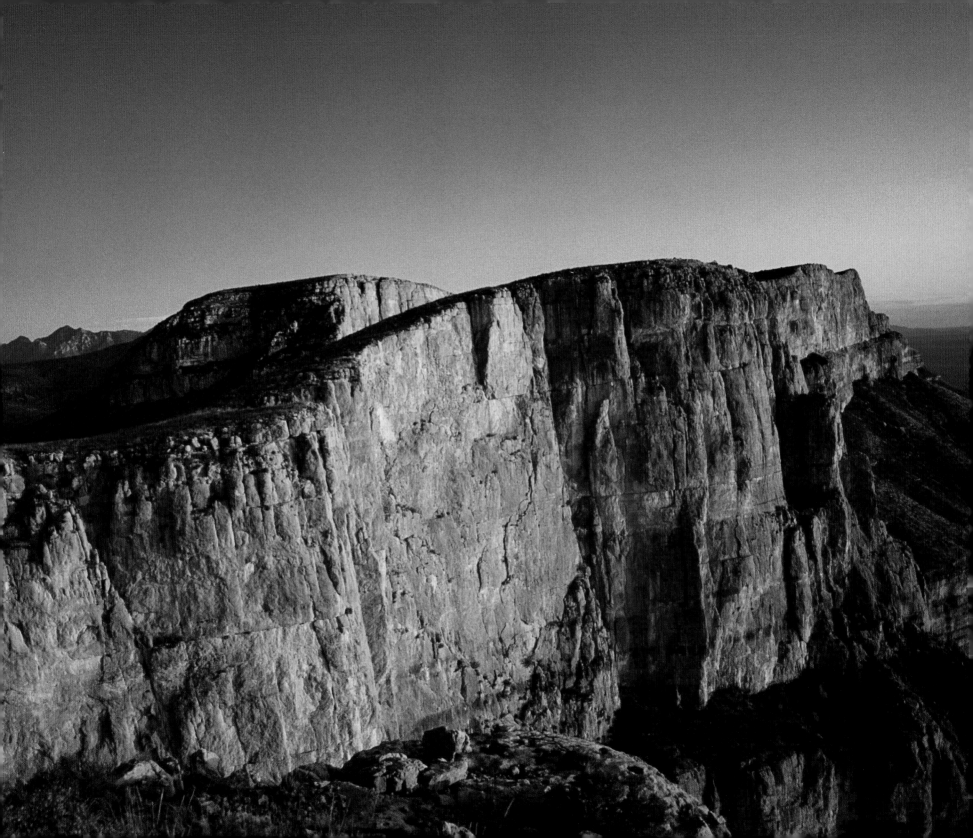

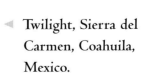

Twilight, Sierra del
Carmen, Coahuila,
Mexico.

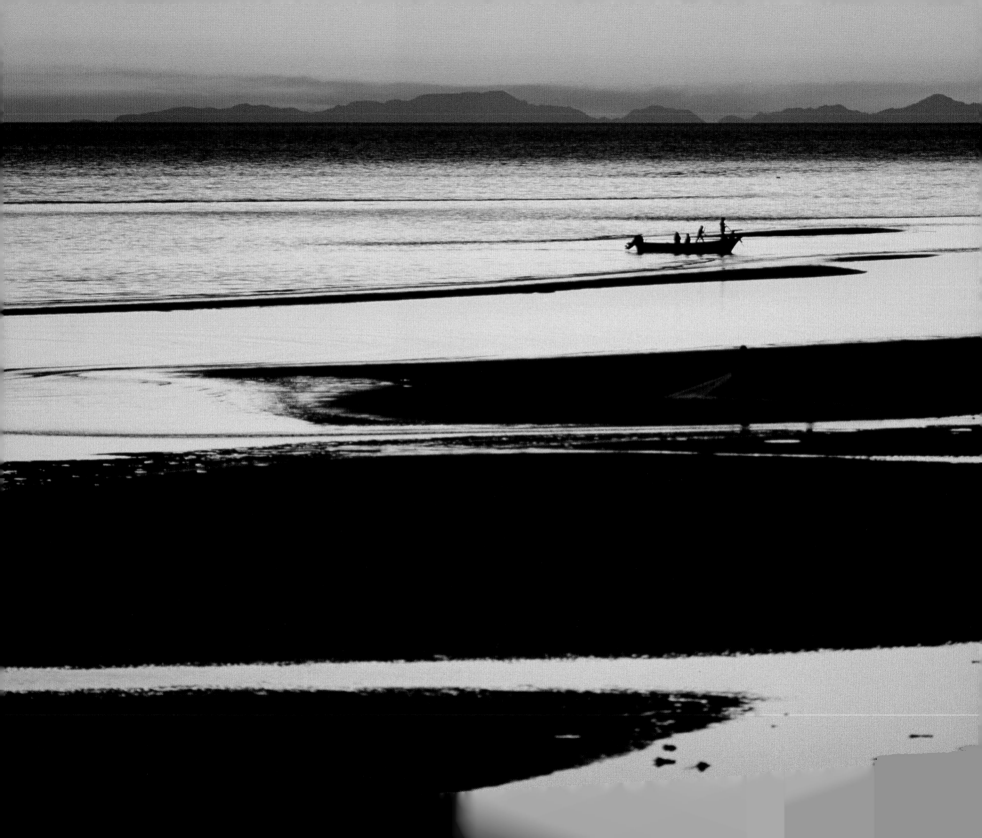

~ *Mysterious Lands* ~

Tiburon Island in the Gulf of California has long been shrouded in mystery. . . . For two centuries strange stories circulated throughout the Southwest about the warlike Seris and explorers who set out for Tiburon and were never heard from again.

—Neil Carmony and David Brown, *Tales from Tiburon*

I PEERED OUT OF MY SLEEPING BAG AND SQUINTED AT A dreamy sun winking over the silver crest of the Sierra Seri, turning the Canal del Infiernillo (Channel of Little Hell) into a river of pink light. Tidal riffles lapping against the rocky shoreline belied treacherous currents that separated my island camp from mainland Mexico. The gentle sound of water lulled me back to sleep until the shroud of pink fog burned away, exposing blue skies that cried with seagulls, ospreys, and shorebirds. I sat up and lit my small stove. The aroma of boiling coffee grounds teased the salty air. I nursed several hot cups of *café con leche* as I watched

droplets of dew evaporate off necklaces of white seashells that glistened along shore. Porpoises breached the glassy surface of the Gulf to the east, and lizards scurried across the rocky *bajada* to the west. These were the sights, sounds, and contradictions that had lured me back to a world that, some had claimed, time forgot.

The day before I'd ridden in a *panga* (small boat) that belched oily fumes as it bounced across the horizon of white caps from the west coast of Sonora toward the black carapace of Tiburon Island. It floated in a mirage called the Sea of Cortez, distorted by what John Steinbeck had written was "a curious illusion caused by light and air and moisture." And it beckoned me with a dream: I could taste life as a castaway on the eve of the 21st century while I explored the ancient homeland of the Seri's creator, Hant Hasóoma, the mythical desert spirit. My captain was a Seri fisherman. His name was Ernesto Molino. And he clearly understood my intentions as he eased his *panga* onto the shell-covered strands of Tiburon Island. We unloaded my gear together: two five-gallon water containers, a crate of canned food, white gas, and a pack. *"Cinco días,"* I said, holding up five fingers. *"Cinco días,"* he said, laughing, trying to bait me with doubts about whether I'd ever be heard from again. We shoved the *panga* into deeper water, and then he hopped in, started the motor, and sped across the empty straits. I was now standing alone in one of the most deserted, enchanting, and mysterious landscapes I knew of in

PREVIOUS SPREAD:
Seri fishermen, Channel of Little Hell, Sonora, Mexico.

▶ **Seascape, Sea of Cortez, Sonora, Mexico.**

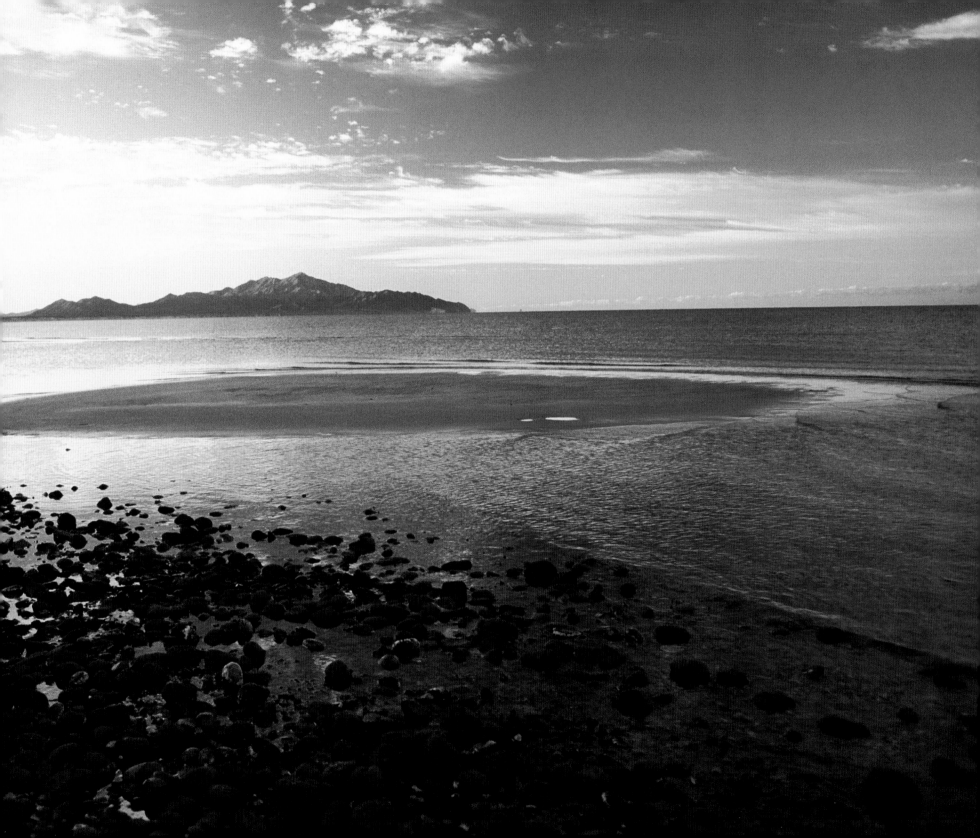

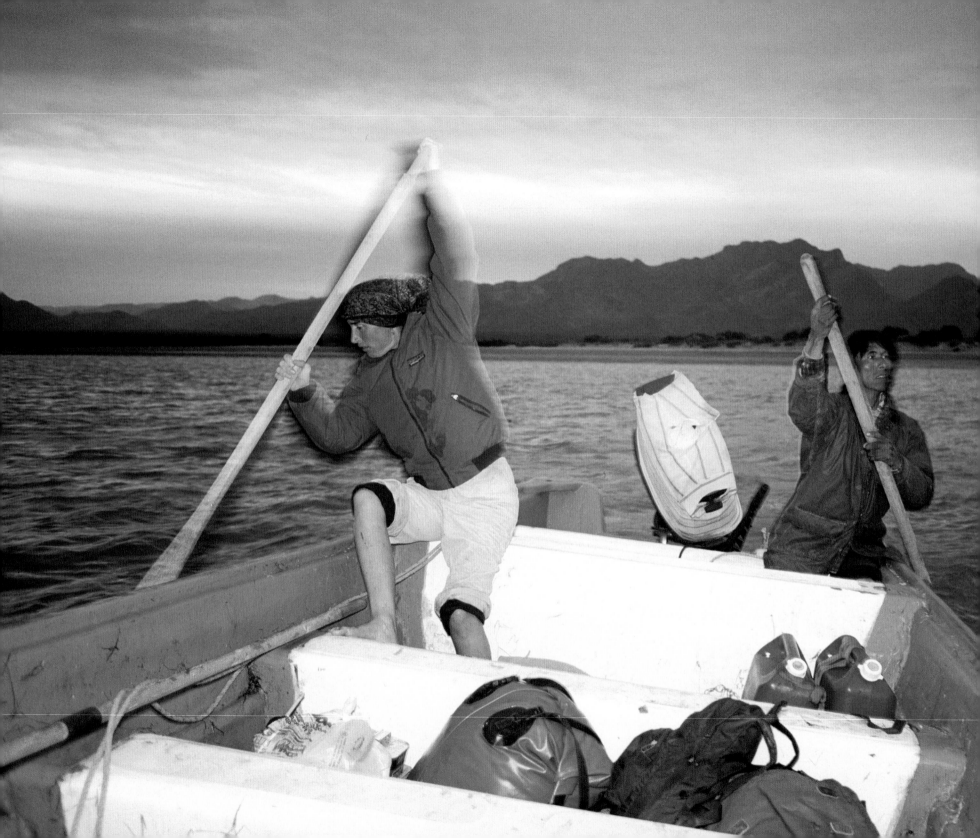

Ernesto Molino
and Louise Teal,
Channel of Little
Hell, Sonora,
Mexico.

the 106,000-square-mile Sonoran Desert. Stretching south from the prospectors' crypt of Arizona's Superstition Mountains to the wave-battered tip of Baja California Sur, it was North America's hottest desert—and the Seri's home.

I first saw Tiburon Island from the cramped seat of a single-engine Cessna fifteen years before. As the pilot circled overhead, I pressed my nose against the window, startled to see the Channel of Little Hell teeming with hammerhead sharks. It was a frightening sight for someone who didn't trust small planes. But it was the kind of view that may have inspired Spaniard Francisco de Ulloa to name the lonely island Isla Tiburón (Shark Island) when he sailed up the Gulf and discovered the Colorado River Delta in 1539. A century and a half later, Spanish soldier Juan Bautista de Escalante journeyed across the *Desierto Purgatorio* (Purgatory of the Desert) from the east and unleashed a bloody reprisal against the Tiburones, slaughtering untold numbers of Seri on the island. That was beginning of what historians predicted would be the end of the *Comcáac* (the People), who first migrated from the Land of the Giants on the Baja Peninsula long ago. Using the Midriff Islands of Ángel de la Guarda, San Lorenzo, and San Esteban as temporary ports of call during their dangerous gulf voyages on flimsy balsa rafts, many Seri settled on the 467-square-mile Tiburon Island. It was the heart of Mexico's Galapagos, where osprey nested in towering *sahueso* (cardón

cactus), where fourteen different kinds of sea turtles once swam in rich Gulf waters with the endangered *vaquita*—the smallest porpoise in the world—and where the Seri carved sharks, roadrunners, and turtle harpoons from *palo fierro* (ironwood), the second hardest wood on the continent. Like much of Seriland in the hellish deserts on the west coast of Sonora, Tiburon Island was also known for its paucity of waterholes, and together they formed what plant ecologist Ray Turner described as "some of the most inhospitable landscapes in North America."

I hoisted my pack, turned my back on the Channel of Little Hell, and walked into this landscape. I was headed for water, and then to the summit of the 2,871-foot Sierra Kunkáak (Mountains of the Seri People), where I hoped to photograph the Seri's deserted island homeland from above. I walked briskly across the seaside *bajada* toward a canyon mouth that drained the east face of the Sierra Kunkáak. The literature had prepared me for the worst. But compared to Picacho del Diablo, two hundred miles across the Sea of Cortez to the northwest, and the Big Bend frontier, five hundred miles across the Sierra Madre Occidental to the east, the walking was easy and enjoyable. The salt brush, ocotillo, and pitaya agria slowly gave way to the sight of thick-antlered *buros* (mule deer) that darted like ghosts through the palo blanco, elephant trees, and senita cacti. But each incremental change in elevation and vegetation was marked by the sight of another rattlesnake. The first one I saw fifteen minutes from

▲ **Dawn, Channel of Little Hell, Sonora, Mexico.**

▶ **Saguaro skin and needles, Ironwood Forest, Arizona.**

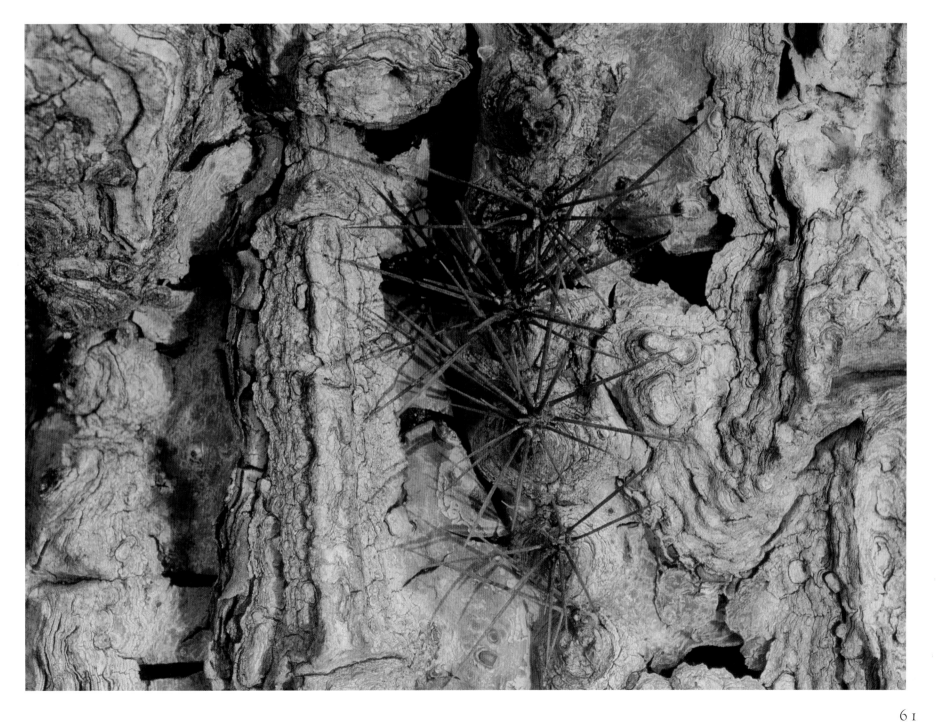

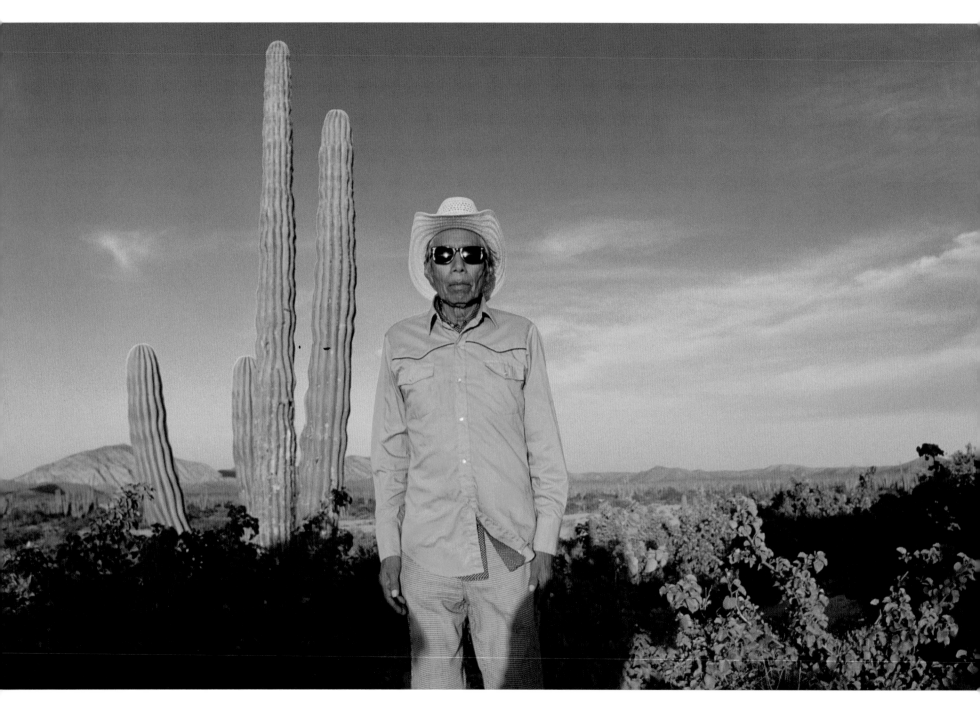

camp almost made me jump out of my skin. I'd grown up around rattlesnakes—hiked, ran, climbed, and rafted in their midst—and in my teens I'd caught, cooked, and eaten them until I'd had my fill of the stringy white meat. But Tiburon's diamondbacks, I discovered, were aggressive, and they stood their ground. This one was no different. It was thick as an exhaust pipe and gave the textbook warning rattle. But instead of slithering away under a torote bush, it lay there coiled in defiance, its forked, pink tongue tasting the air for movement—in case I had any doubts about who was at the top of the island's food chain. I gave it a wide berth, turned to make sure it wasn't slithering behind, and walked with a new hop in my step. By the time I reached the mouth of the barranca, I'd hot-footed around two more diamondbacks, no less aggressive than the first. I learned later, a German hiker was reported to have died that year from a rattlesnake bite on Tiburon Island.

I was following an ancient trail across the desert from the coast, first used by the Seri to reach a precious water hole called Pazj Hax (or Tinaja Anita). Many have used it since. One of the first strangers to drink its life-saving waters may have been an eighteen-year-old woman named María Dolores "Lola" Casanova. She was spirited away by Iguana-Coyote, a Pima chief, during a deadly Seri raid on Las Palmitas, Sonora, in 1854 and taken to Tiburon Island, where she lived as a captive until Iguana-Coyote died of old age.

◄ **Eujenio Morales
in Desierto
Purgatorio
Sonora, Mexico.**

Following the mythic trail through sacred palo blanco trees the Seri believe can hear the whispers of men, the beautiful, tattoo-covered "White Queen of the Seri" has floated across this landscape for 150 years.

Lola Casanova may have been the first outlander to live on Tiburon, but she was not the last to travel to the mysterious island Edward P. Grindell wrote of after his brother Thomas perished trying to reach it in 1905: "None who have ever penetrated into the heart of Tiburon have returned to tell of its wonders." The body count seemed to substantiate Grindell's claim. Two American adventurers, R.E.L. Robinson and James Logan, were shot and killed by the Seri on Tiburon in 1894. No one knows for certain why. Two years later prospectors John Johnson and George Porter were also killed on Tiburon. No one knows why.

During Thomas Grindell's own ill-fated expedition, he and two other men died of thirst, and search parties discovered the severed hands of a white man nailed to a plank. No one knows who they belonged to. Outsiders accused the Seri of cannibalism. But conservationist and bighorn-sheep hunter Charles Sheldon proved that the accusation was culturally and ritually unfounded. Against the advice of locals, the Vermont native and Yale graduate went to Tiburon Island alone in 1921 and hunted deer for starving Seri living on the island. But tales of the "wild" Indians became part of the lore that

▲ Senita cactus and palo blanco, Tiburon Island, Sonora, Mexico.

► Sunset, Saguaro National Park, Arizona.

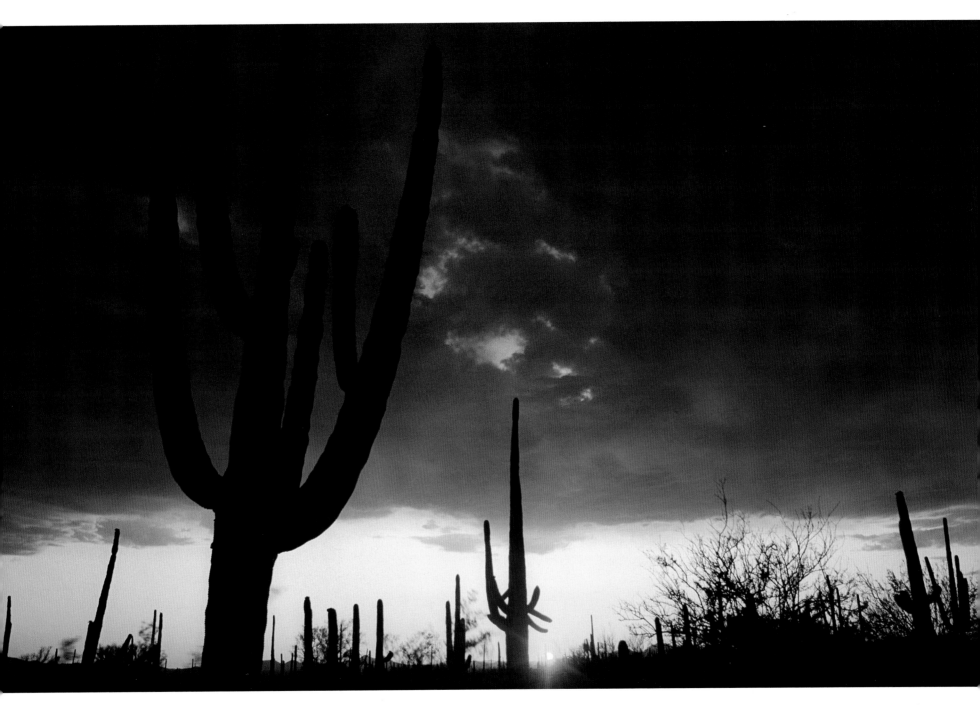

continued to entice gold seekers to the lost world of the Seri.

When I reached Pazj Hax, I crawled on my hands and knees through the carrizo that the Seri once used to make reed balsas, and I filled up my gallon jug with a metal cup. I gathered wood for a fire, then rolled out my sleeping bag at the foot of a huge cliff fig. Come morning, I climbed up the barranca to a small *tinaja* (rock tank) and spent most of the day staring across the snake-infested *bajadas* that fanned out from the Sierra Kunkáak to the blue channel, taken by the Seri's ability to survive for two thousand years on the meager rations of the desert and the sea in what ethnobotanists described as "one of the hottest and most arid environments ever to be permanently occupied by humans."

As shadows crept down the walls of the barranca, I crawled out of my refuge and climbed steadily through the avalanche of boulders to the summit of the Sierra Kunkáak. I sat motionless, mesmerized by the palo blanco trees that swayed in the desert breeze. Somewhere nearby the Seri once visited a sacred cave where they sought "miraculous power" through visions from the spirit world in Taheöjc Imozit (the heart of Tiburon). I'd come for similar reasons: the vision of what their ancestral land looked like years after they were forced to abandon it for exotic bighorn sheep that were transplanted here in their stead. The island was indeed mysterious and beautiful, but without the Seri, it had become another *despoblado*. Yet something lingered.

Night fell. I lay down in a bighorn sheep perch beneath the

▶ **Hohokam shell trail, Barry M. Goldwater Range, Arizona.**

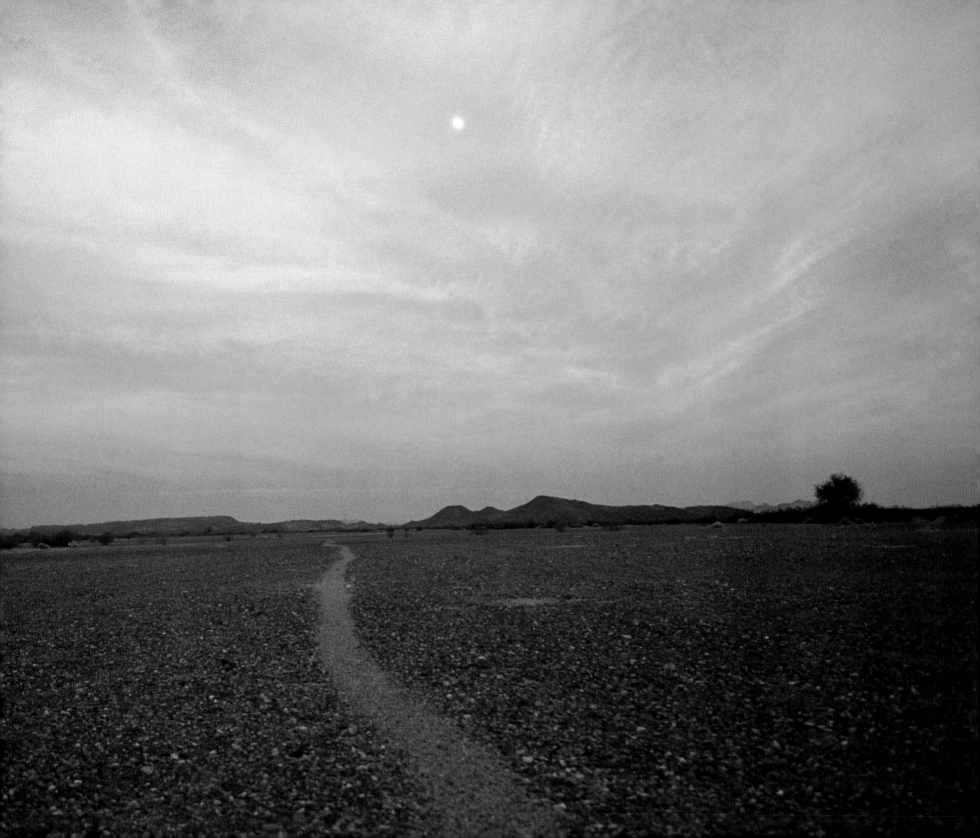

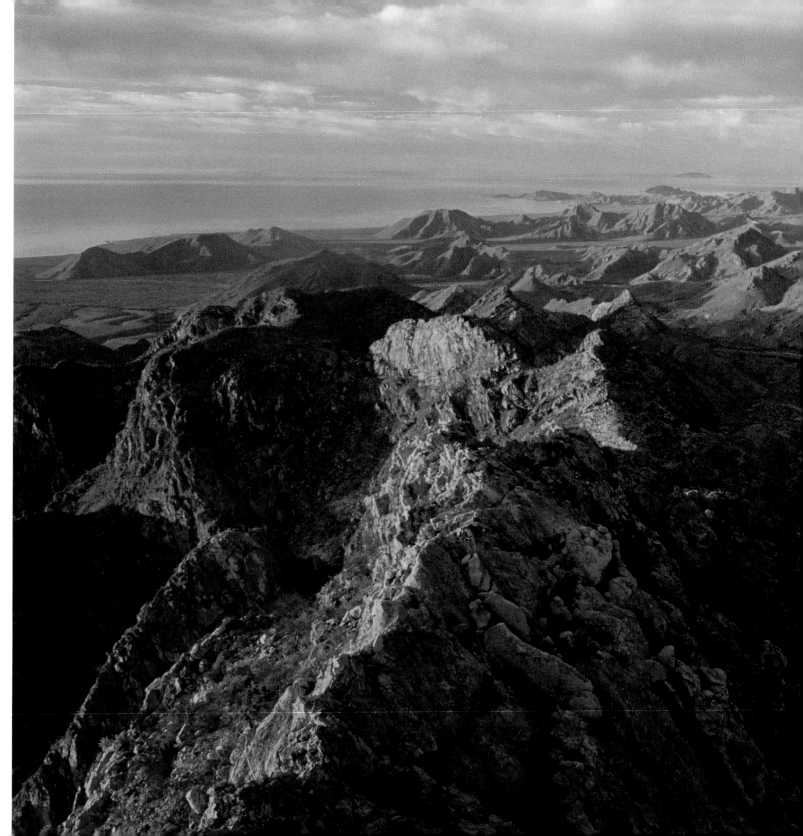

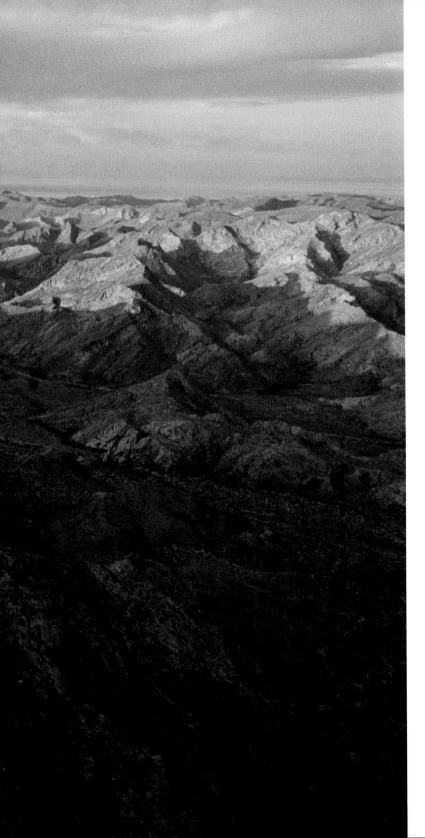

craggy summit and remembered the words of a nineteenth-century surveyor: "There is no place, just like this place, anywhere near this place, so this must be the place." There was no place like Tiburon, and years after Ernesto picked me up from my five-day exile, the spirit of the Seri world called *iʔišitim* (their place) continued to feed my soul long after I returned from repeated journeys to the world of Hant Hasóoma.

◀ **Sierra Kunkáak,
Tiburon Island,
Sonora Mexico.**

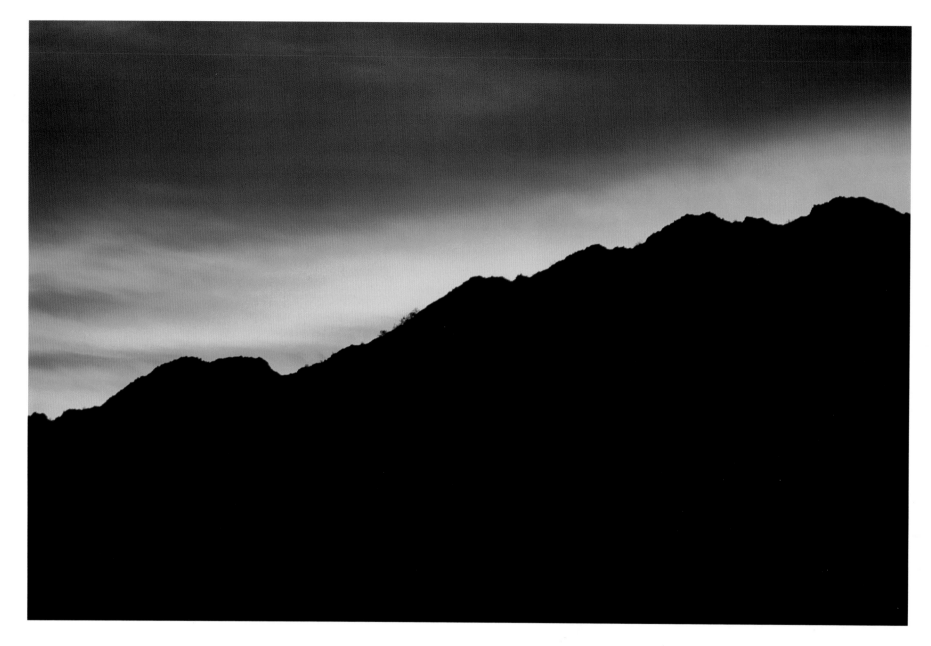

▲ Dawn, Sierra Pinta,
Camino del Diablo,
Arizona.

▶ Sunlight and storm,
Baboquivari Peak, Tohono
O'odham lands, Arizona.

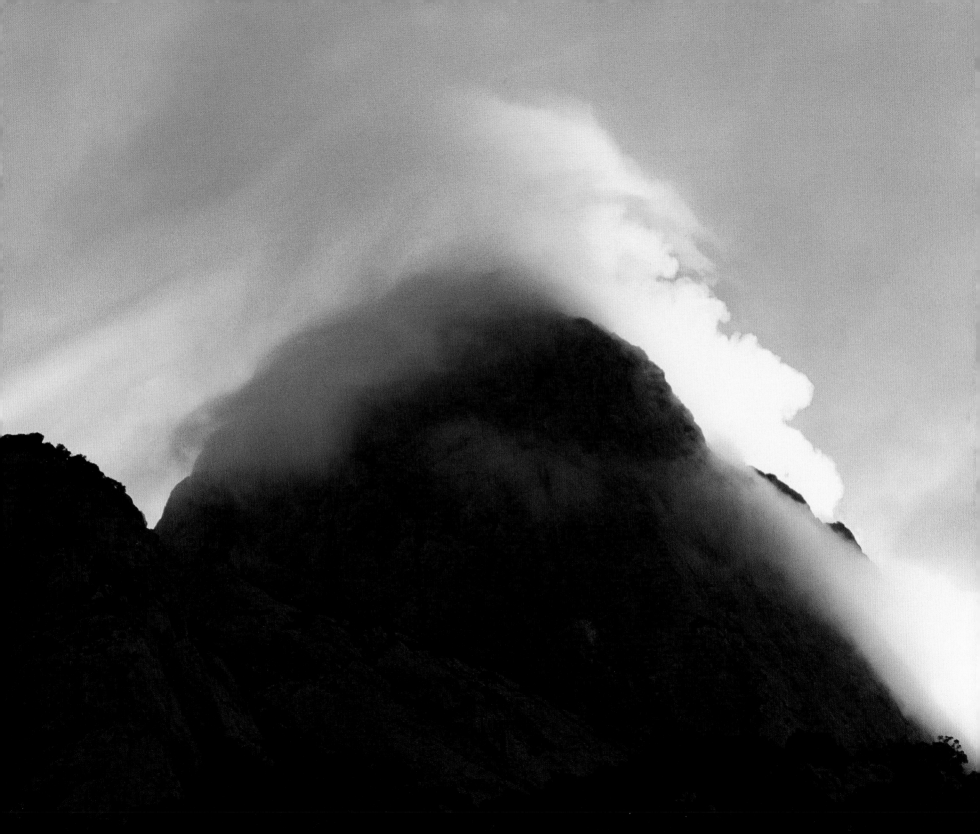

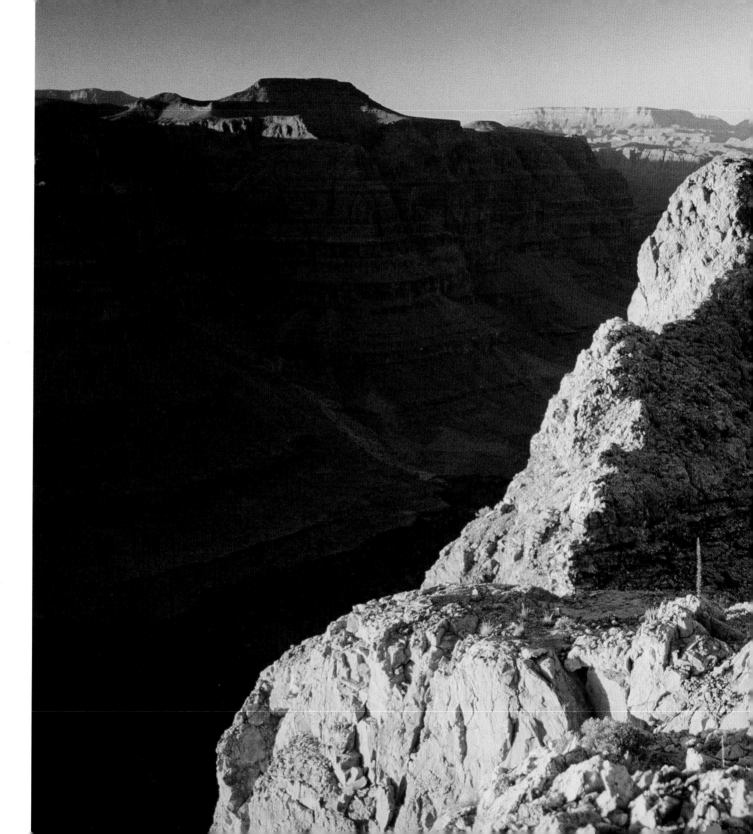

▶ Dave Ganci on
Diamond Peak,
Western Grand
Canyon, Arizona.
Mojave Desert.

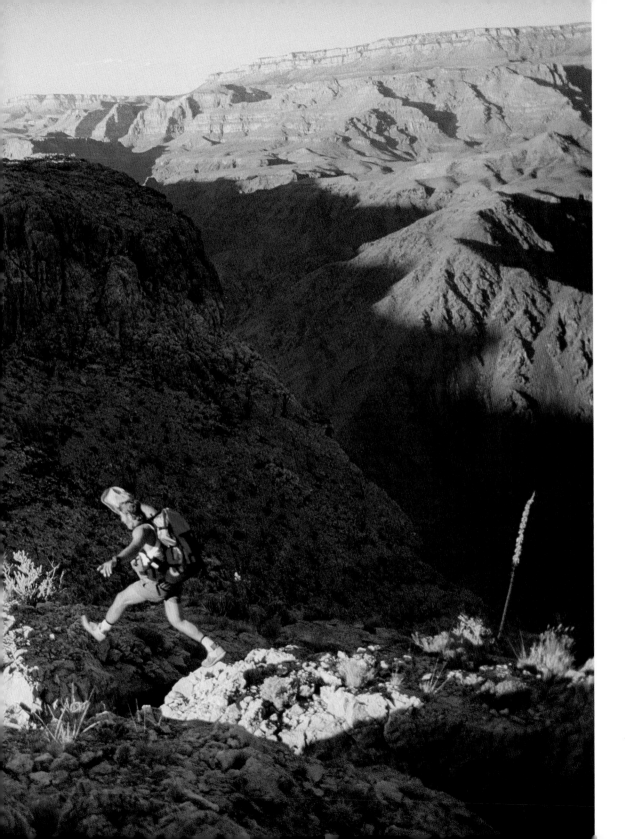

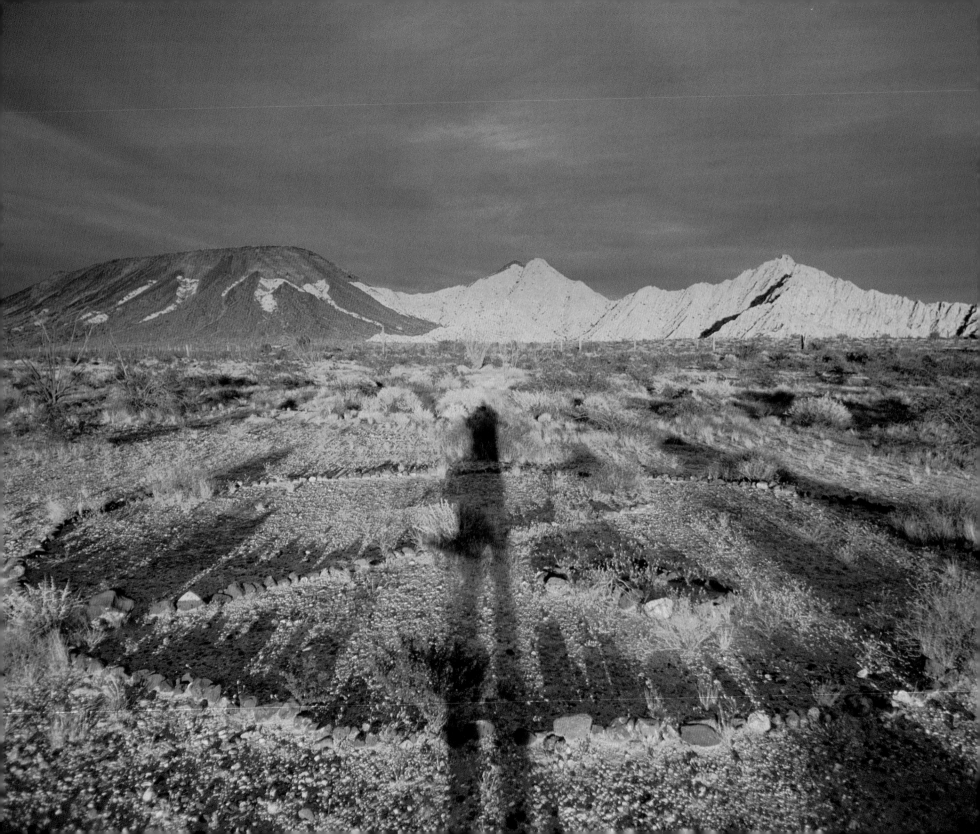

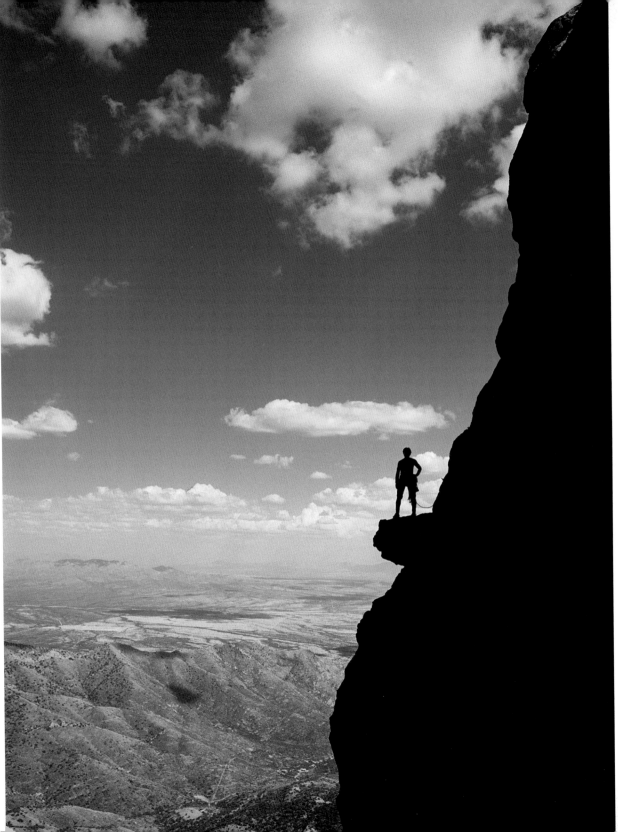

◀ Climber,
S.E. Arête of
Baboquivari Peak,
Tohono O'odham
lands, Arizona.

◀ ◀ Sun dial,
Circle of 8 grave,
Camino del Diablo,
Arizona.

75

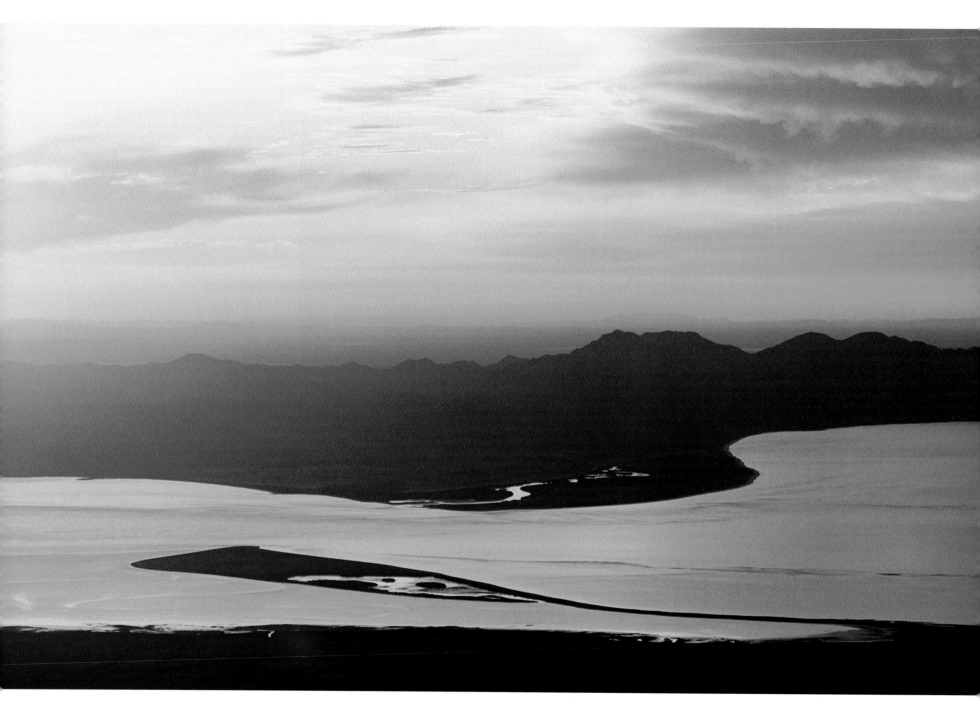

◀ Sunrise, Channel of
Little Hell, Sonora,
Mexico.

▲ Moonrise, Chemehuevi
Mountains, California.
Mojave Desert.

77

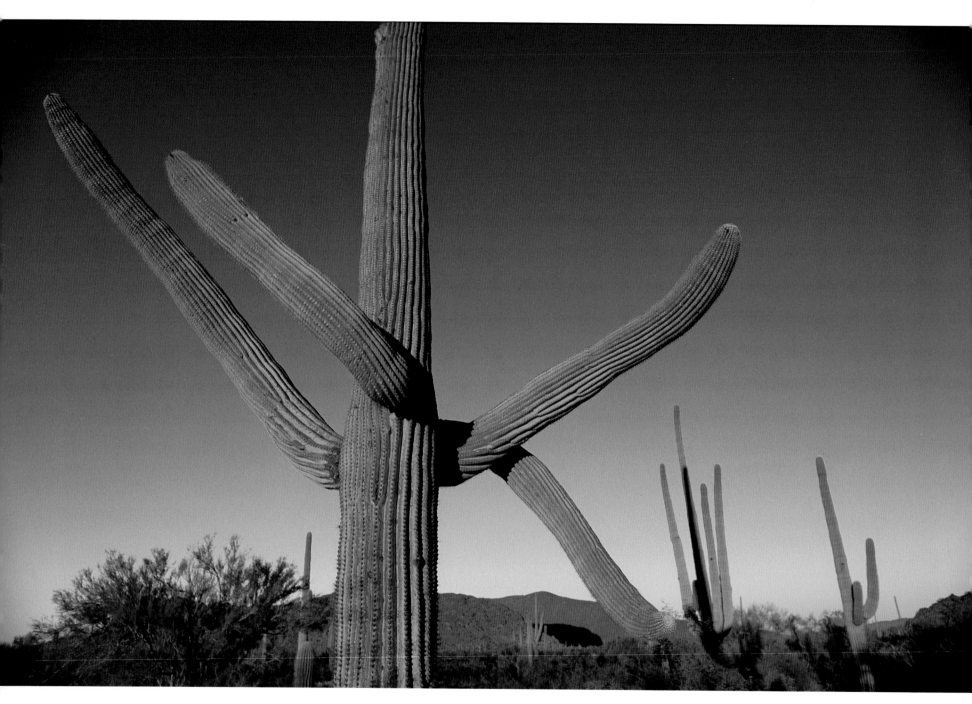

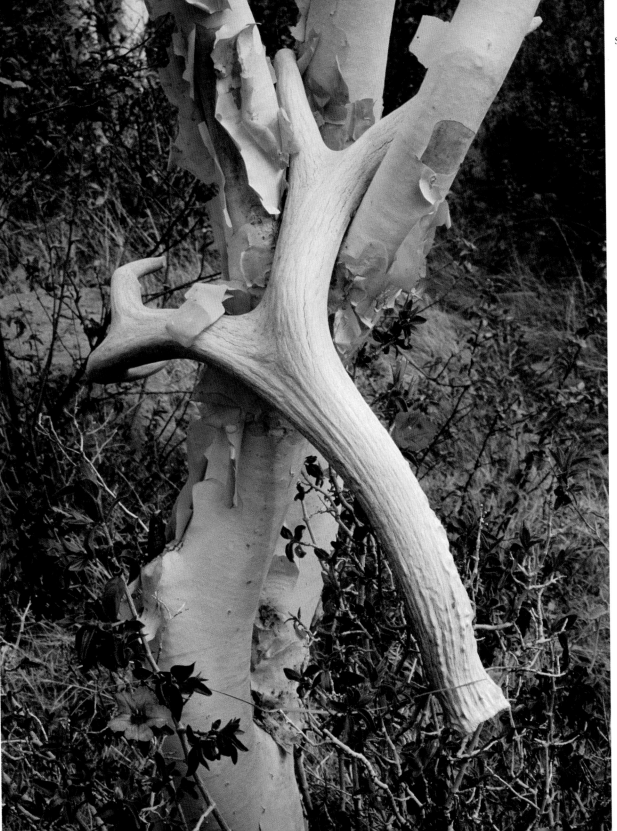

◄ Antler and
palo blanco,
Tiburon Island,
Sonora, Mexico.

◄ ◄ Saguaro,
Camino del Diablo,
Arizona.

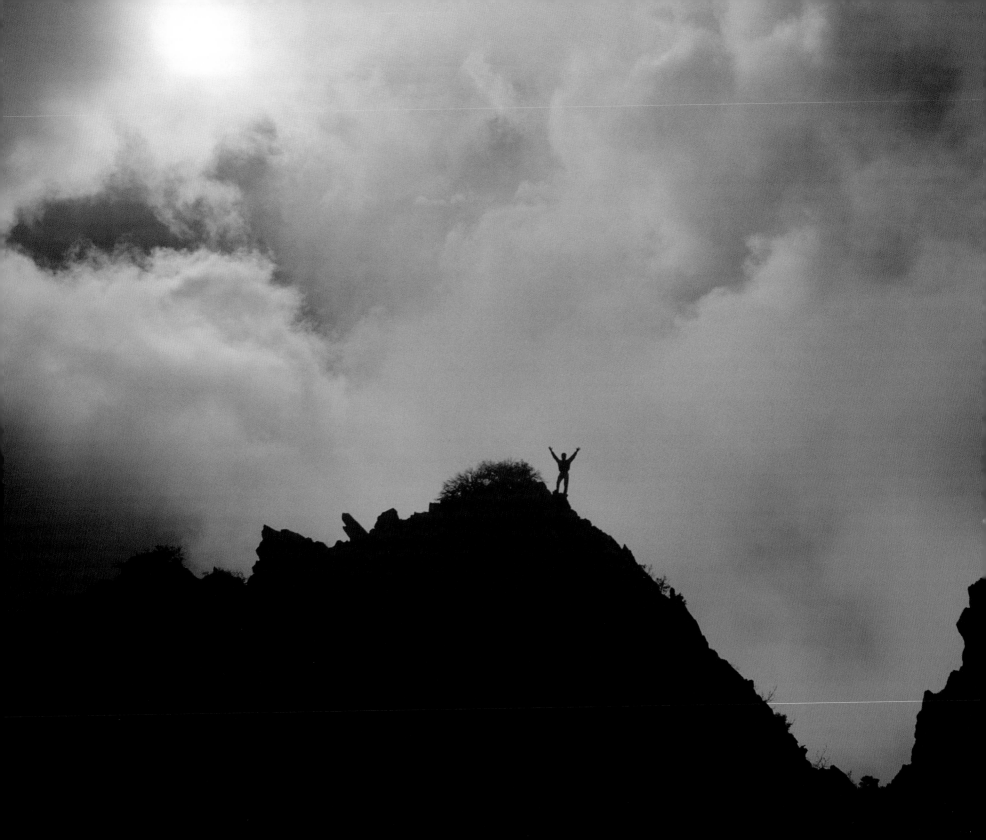

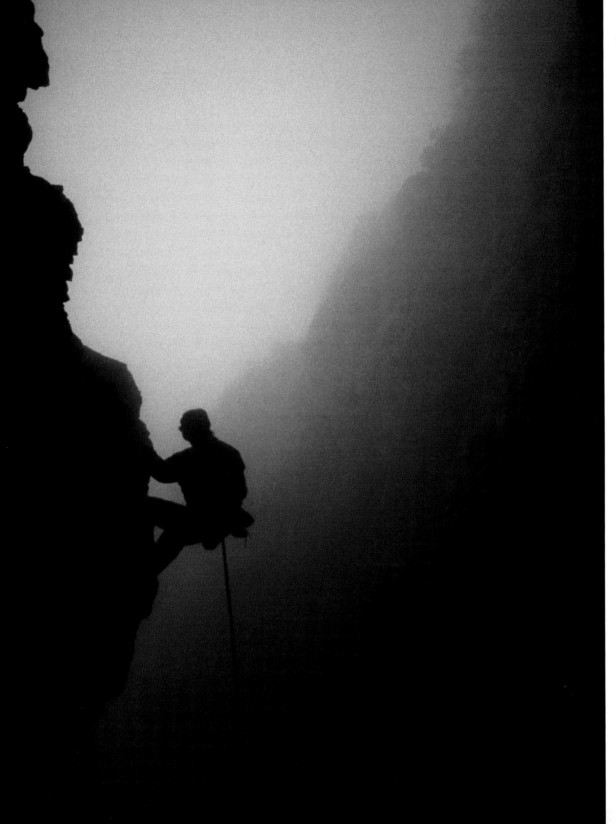

◄ Descent into the
mist, Mazatzal
Mountains,
Arizona.

◄ ◄ Sacred
Mountain,
Wikedjasa
("Chopped-Up
Mountains"),
Arizona.

81

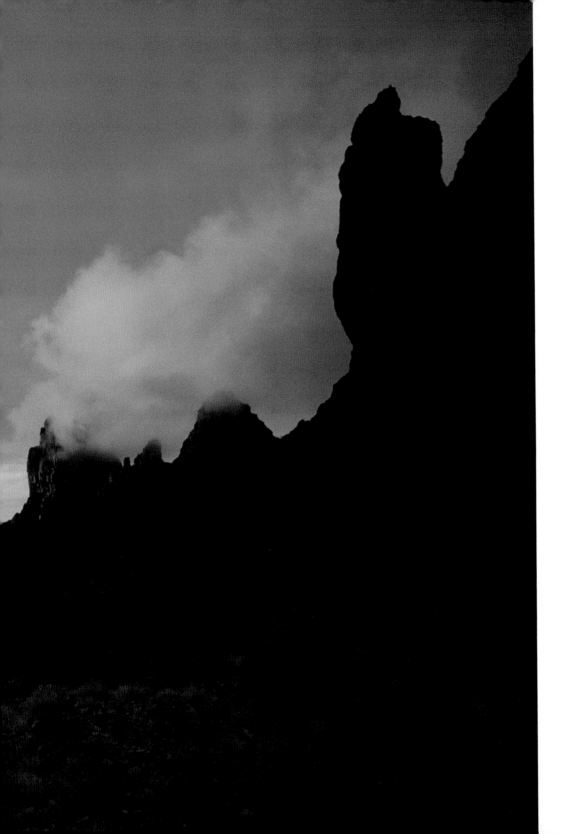

◄ Horns of the
desert, Kofa
Mountains,
Arizona.

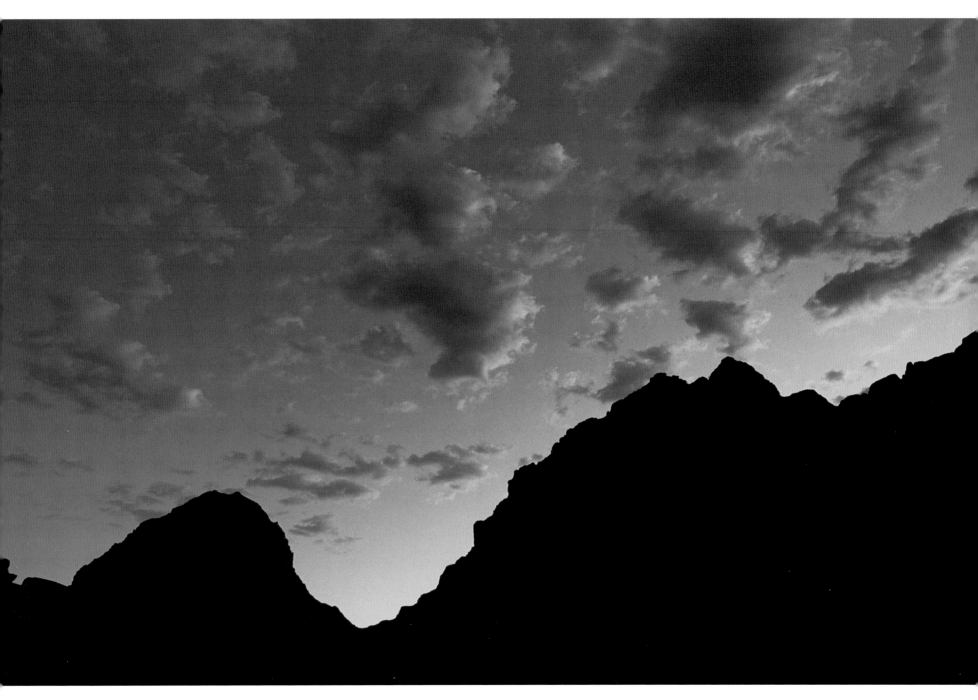

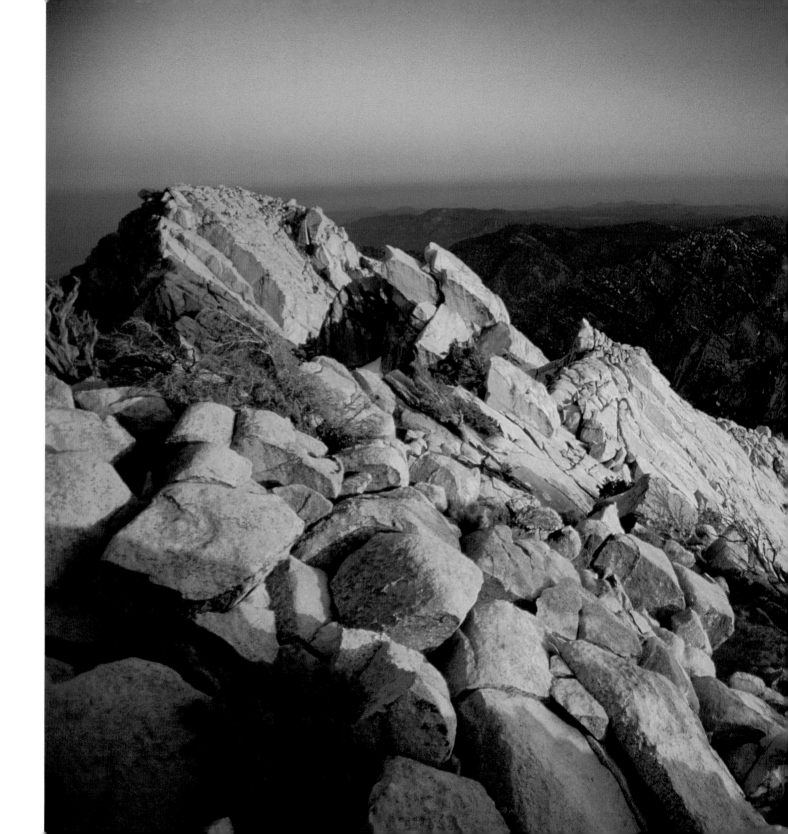

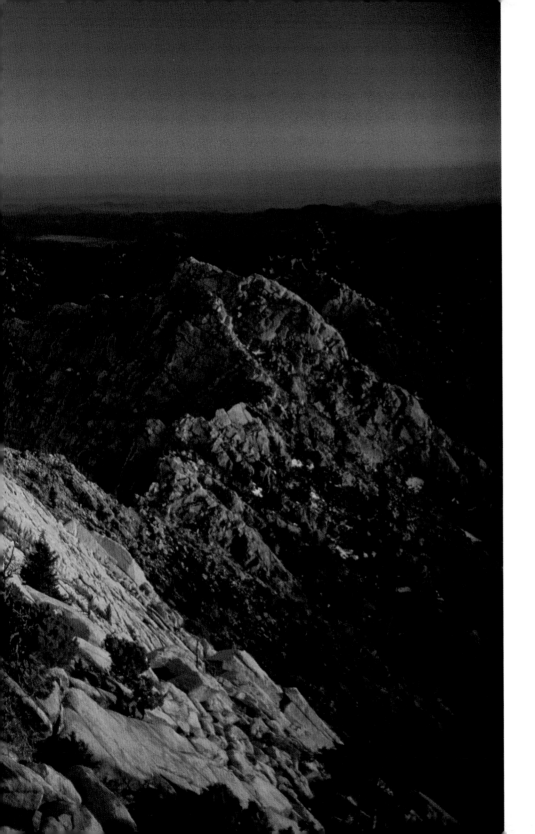

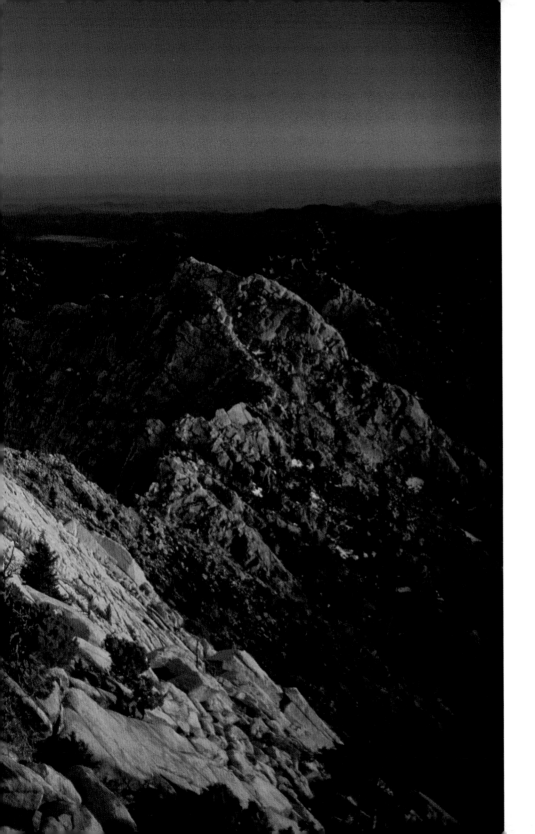 Summit crest,
Sierra San Pedro
Mártir, Baja
California Norte,
Mexico.

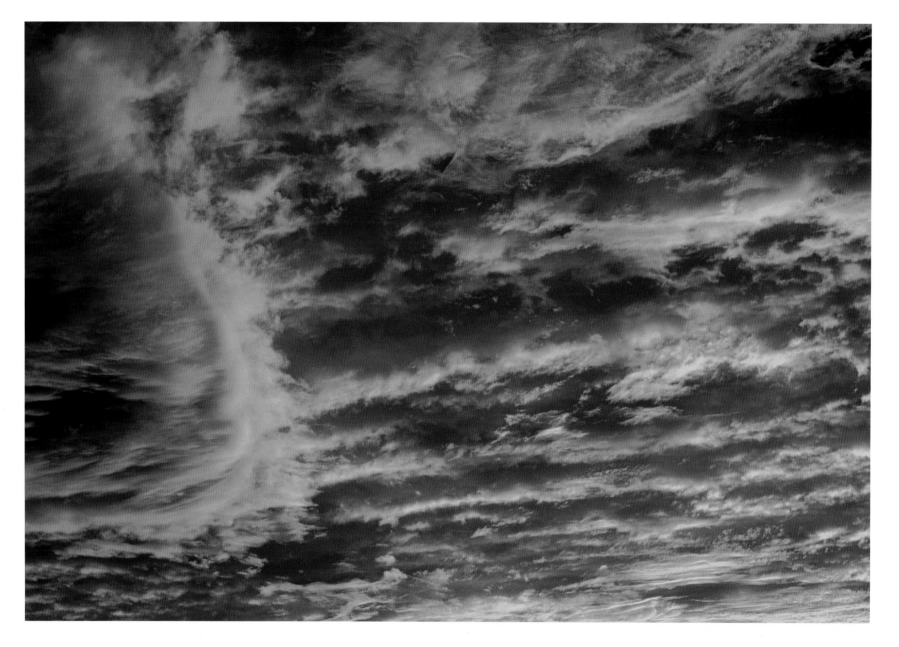

▲ Western sunset, Tucson
Mountains, Arizona.

▶ Sunrise, Salton Sea, California.
Mojave Desert.

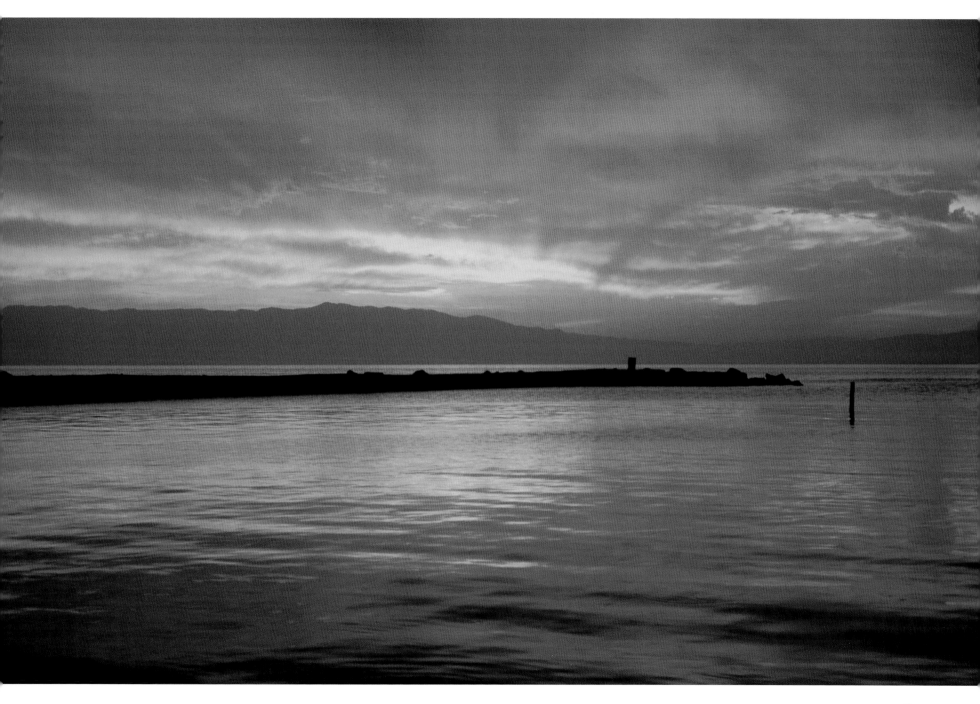

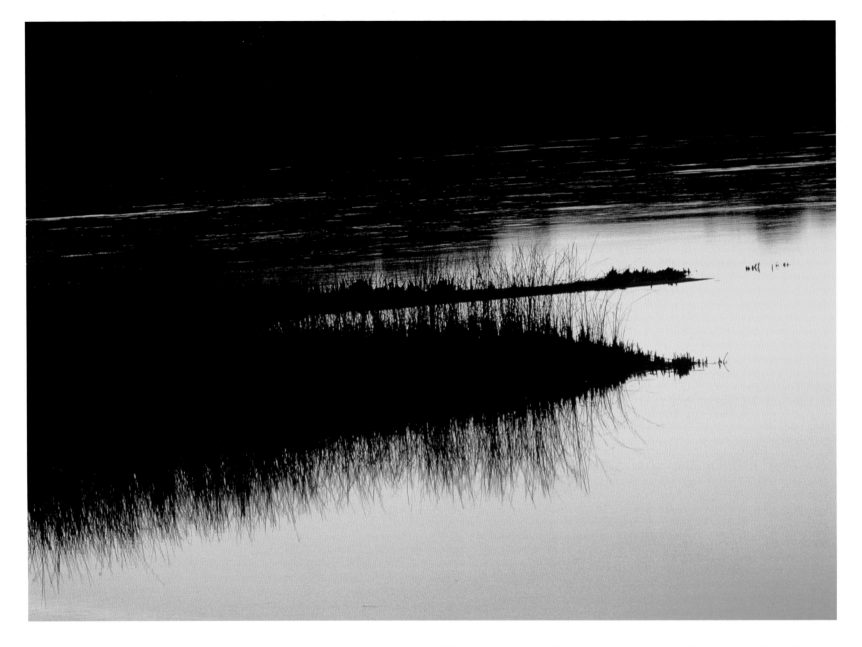

▲ Río del Tizón, Colorado River,
Arizona and California.

► Kristen Huisinga in Fern Glen
Canyon, Arizona. Mojave Desert.

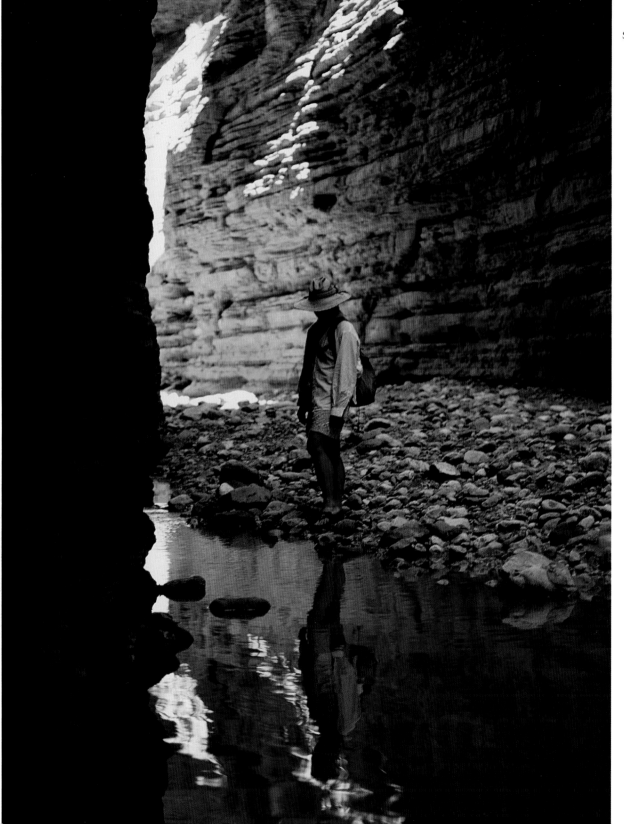

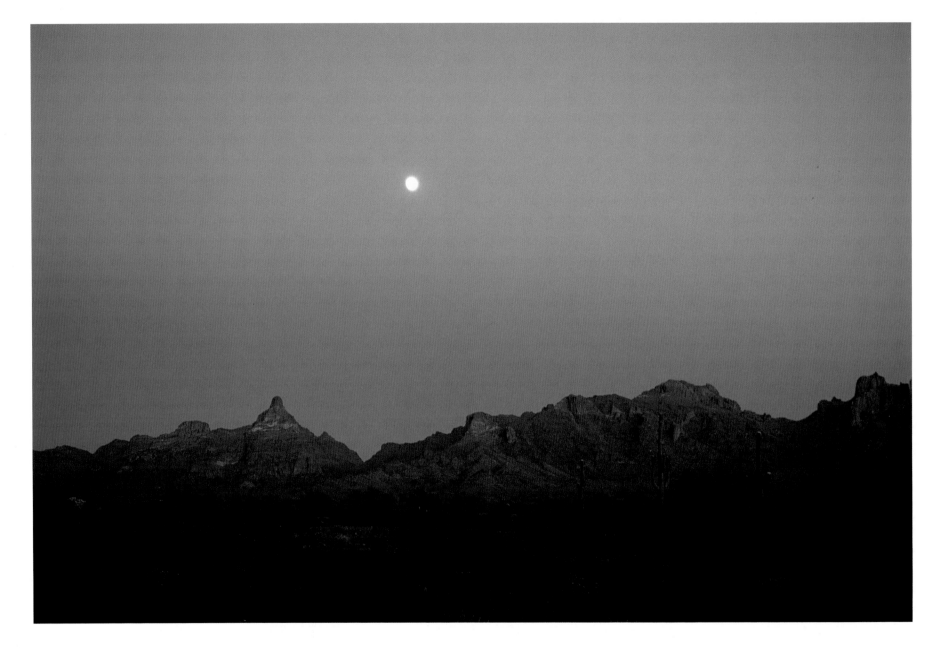

▲ Moonrise, Sierra del Ajo, ► Signal Hill, Saguaro National
Organ Pipe, Arizona. Park, Arizona.

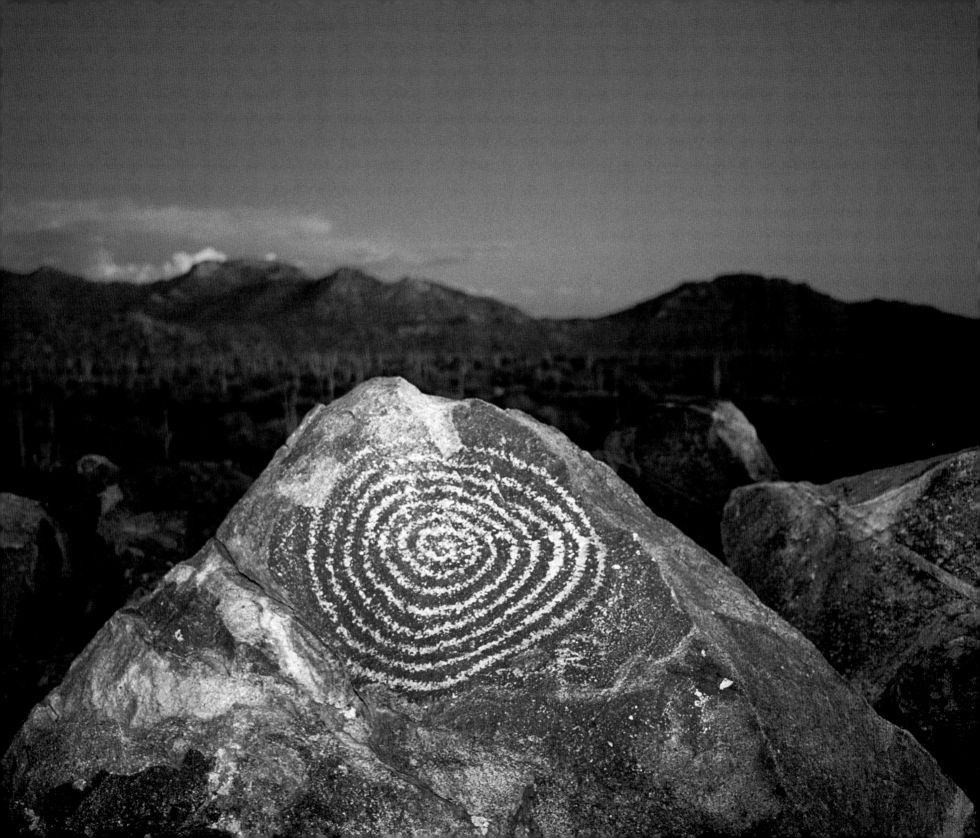

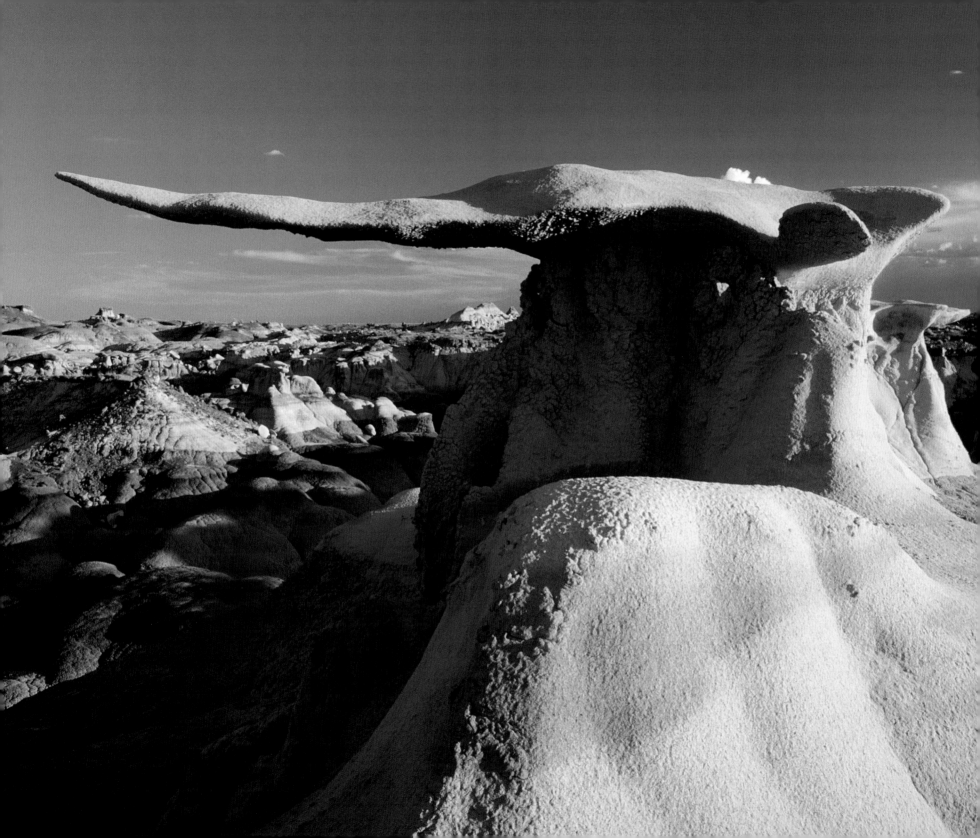

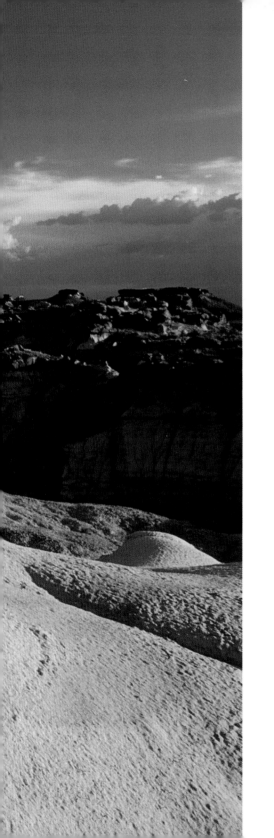

~ *Haunted Land* ~

Gods sing to you and then drop down a trap door
into the past. Water slithers away like silk and is gone.
The answer slips like sand through your fingers. . . .
You call out for help and get an echo back.

—Rob Schultheis, *The Hidden West*

I SAT IN THE TRUCK, DEBATING WHETHER I SHOULD OPEN the door and retrace my footsteps into badlands that stretched to the black horizon as far as I could see, or whether I should turn on the ignition and drive across the Desierto Pintado (Painted Desert) all the way back home. I was torn, pulled in both directions by promise and fear. It was 5:30 PM. It was hot and muggy, and an electric wind blew through the open windows of my pickup. Angry, revolver-blue clouds smothered the obsidian landscape, holding me hostage with dread. I got out of the truck and weighed the risks as sheets of stinging sand cut across the ground.

In the distance, blue thunderbolts drilled the four directions

of the Navajo world called *Dinetah* (The Land). But plateau winds blew across cedar-covered, gray mesas and kept the thunderstorms at bay. If the monsoons suddenly swept in, I could duck the threat of lightening by walking in the lee of the mesa cliffs. It was an easy hour's walk across barren soil into the heart of the hoodoos, so distance was not holding me back. Nor was it a fear of traveling alone for the first time into country I did not know.

I'd spent the previous two days exploring a whimsical landscape that hosted some of strangest landforms I'd ever seen in the thirty-thousand-square-mile Painted Desert. The first day the gods smiled on me, blessing me with luminous light that had earned this bewitching mile-high country the name Land of Enchantment. The second day, the clouds turned gray and blue, and doubts about re-entering the badlands crept in. A Navajo policeman drove by. I waved. He stopped. And I introduced myself, reading his eyes for the slightest hint that I wasn't supposed to be in the Bisti Wilderness. But he wasn't from around here. He said good-bye and drove off in a rooster tail of dust. Later that afternoon a dark-haired man in an old blue pickup drove by, and I got a *baaad* feeling. I kept looking over my shoulder as I walked back into the badlands.

When I returned to my truck that night, I sat in the cab in case I had to leave with little warning. But my worries seemed unfounded. The warm gentle breeze blowing against my skin

PREVIOUS SPREAD:
White manta,
Bisti Badlands,
New Mexico.

▶ Twilight, West
Mitten Butte,
Monument Valley,
Arizona.

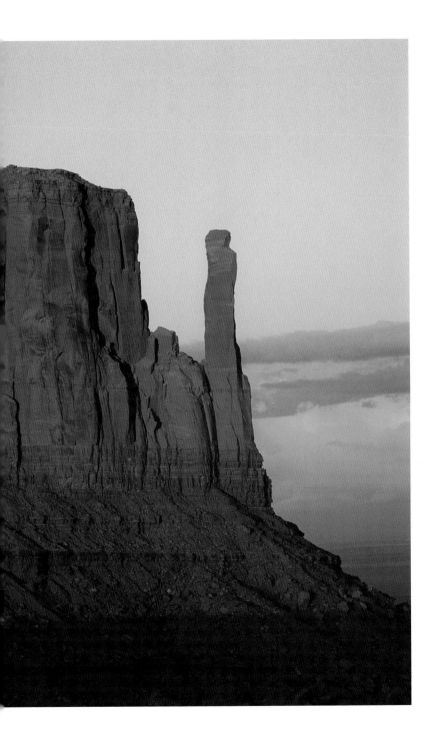

washed away the fears. I got out of the truck and spent one of the most peaceful nights in the desert I'd ever had.

That was yesterday. Something else now kept me riveted to the seat of my pickup. It was nothing I could point to or put my finger on. It was just a gnawing feeling—the badlands now spooked me with their power. God-fearing folks who had traveled west of the Dry Line of the 100th Meridian along the 35th Parallel during the 1850s in quest of Manifest Destiny—or gold in California—called such beliefs "superstitions." Cowboys driving cattle herds north from West Texas on the Goodnight-Loving Trail to Miles City in Montana Territory during the 1860s and 1870s came to know such places as *mal país* (bad country). Medicine men who still carried protective *jish* (medicine bundles), with earth from the four sacred mountains, knew certain lands were haunted by the spirits of soldiers, slave traders, and enemy ghosts who'd harmed their people. There were clan lines of legends; many were based on firsthand accounts, most were steeped in oral tradition and ceremonial sand paintings, and some had become myths because they flew in the face of Euro-American beliefs. By any description, I'd come to rely on my gut feelings over the years and the realization that there were some places you simply weren't supposed to visit—what one Navajo traditionalist called "ghost places."

Was Bisti Badlands such a place? I wasn't sure. There weren't

any warning signs. I kept searching the horizon looking for clues.
There weren't any. I was alone. There wasn't a pickup truck or a
hogan for miles around. And I was plagued with fear. I tried to
ignore it because Bisti was surrounded by the mystical wonders of
Native America that stretched across the Four Corners region of the
120,000-square-mile Colorado Plateau. Many had been celebrated
as national parks and monuments: Canyon de Chelly lay to the west,
Bandelier to the east, Aztec Ruins to the north, and Chaco to the
southeast. This forty-five-thousand-square-acre Bureau of Land
Management wilderness would be dwarfed by Seri country, the Big
Bend frontier, and Picacho del Diablo. Yet it lay in the heart of
Native American lands that included the Zuni, Navajo, Pueblo, and
Ute. Was Bisti a burial ground for victims annihilated by Coronado
who had pushed the limits of his *despobaldo* north of Zuni from
Mexico? Was it an open grave for Navajo murdered while fleeing
the death march of Colonel Kit Carson's Long Walk in the winter
of 1864? Virtually nothing had been written about Bisti that
provided me with the insight I hungered for, except that the word
had been anglicized from the Navajo *Bistahí* (Among the Adobe
Formations). I believe that the mountains, canyons, and deserts of
the world are ruled by the powerful forces of nature, and I try to
abide by those natural laws. I didn't want to believe that the dreams
of evil men hold sway over nature. So I assuaged my fears, ignored

▶ **Bistahí, Bisti Badlands, New Mexico.**

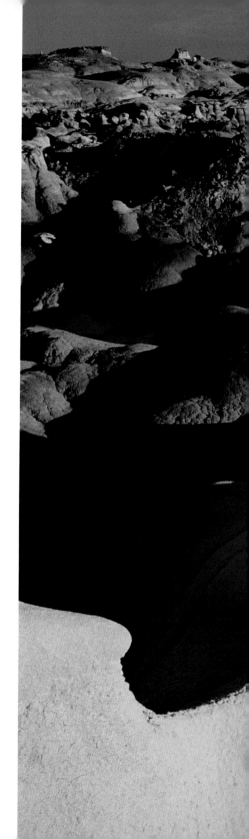

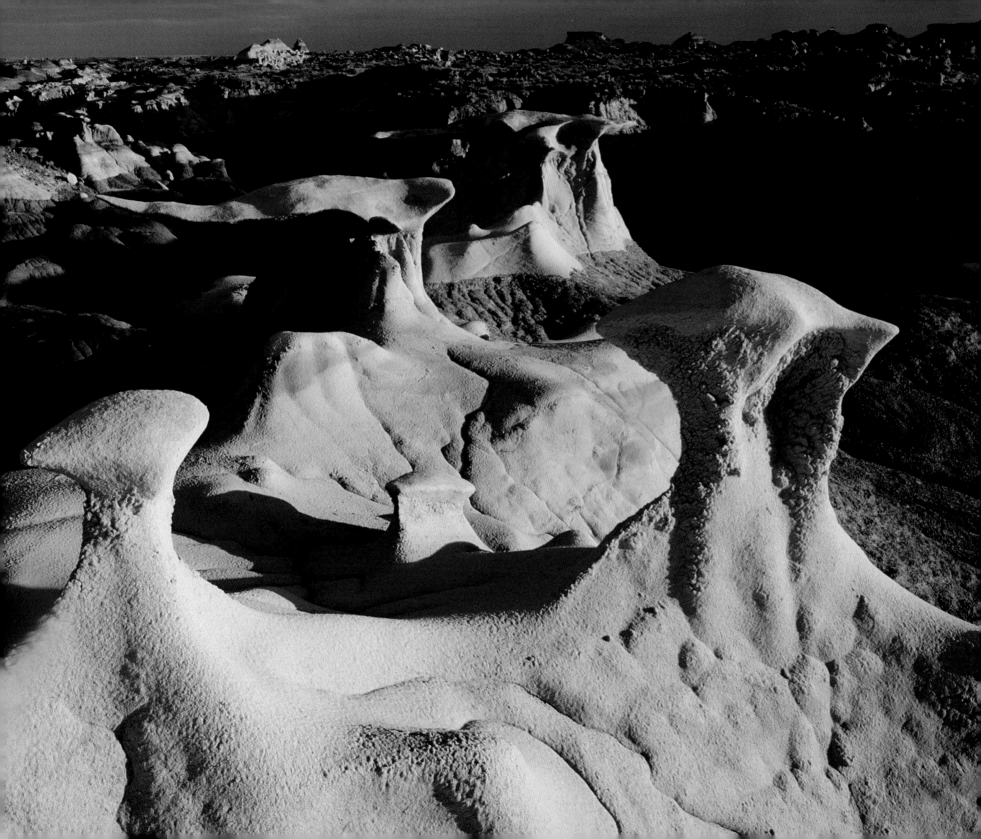

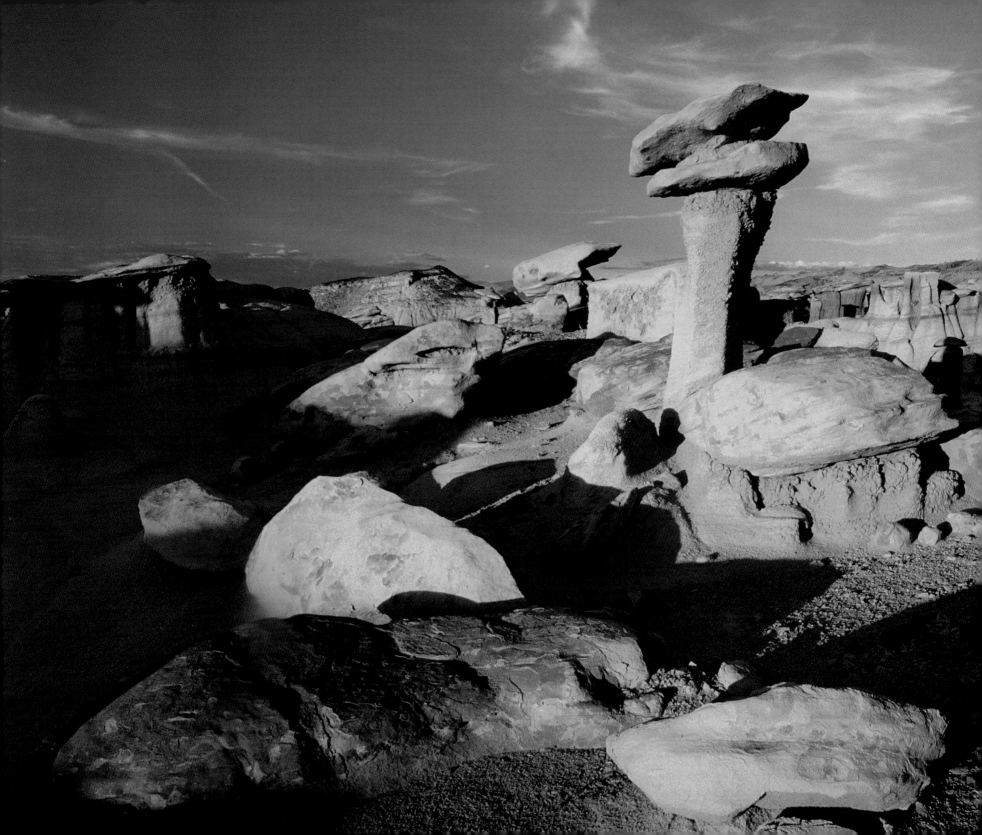

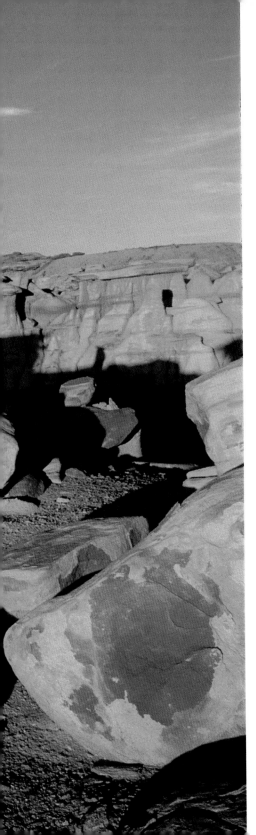

Hoodoo garden,
Bisti Badlands,
New Mexico.

my gut feelings, and fell through a trapdoor into a world where the voices of gods, human wolves, and spirits were said to cry from the ground.

I followed a trail of footprints that snaked across the brittle ground. My steps sounded like eggshells cracking underfoot. The path lead along the base of a short cliff and turned north into a dry arroyo that wound into a labyrinth of gray hills created by an Ice Age mix of sandstone, shale, lignite, and bituminous coal. An ominous feeling came over me. I wrote it off as a mood swing from the sudden drop in barometric pressure and pushed against my fear.

Cresting a short rise, I wandered amongst hoodoos that loomed over me like Zuni Shalakos, tall ceremonial figures. I looked down into a dark-gray canyon. In the gloomy light it looked like a dungeon, inhabited by grotesque stalagmites of mummies that clawed at the black skies from cliffs that had entombed them in clay. A sliver of white caught my eye. It looked like a leg bone. But I couldn't tell if it was the femur of a deer or a human. I bent over to examine it stopping short of touching it. I had the sudden sensation that something terrible had happened here and walked away feeling like I'd been kicked in the stomach.

I clambered through the friable clay and mudstone toward a batwing-shaped hoodoo I'd photographed the day before. I sat there and waited for the light. A single glimmering ray of sunlight

bursting through the suffocating dark skies would do it, and then I could leave. I scanned the western horizon and spotted what looked like a hogan far off in the distance. There weren't any lights on, and there wasn't a pickup out front, but I felt eyes upon me. A chill ran down my spine. I wanted to get up and leave, but I'd come a long way to make these pictures. So I continued sitting there on the edge of the badlands, waiting for the light.

Suddenly I sensed two men running toward me. Then I heard their footsteps in the distance, running up the arroyo from the hogan, and I knew they weren't coming to say *yahtahey* (hello). It grew darker. The footsteps drew nearer. Then I heard their voices. Fear rattled me. So I got up and peered over the edge of the mesa, expecting to see two photographers setting up their tripods. But nothing was out there except voices echoing through columns of dark hoodoos. The hair on the back of my neck stood on end.

Had the man in the blue pickup put something in the water jugs I left in the bed of my truck when I was out here yesterday? I prayed not. I relied on the clarity of vision that came from hunger, exercise, fatigue, and contemplation. Was I hearing the voices of slain Indians crying from a crypt near the leg bone I'd seen earlier? I did not know. Author Tony Hillerman wrote about Navajo witches in his popular mystery *Skinwalkers*. Not to be confused with the Anglican sirens who swung from the gallows at Salem in 1692, skinwalkers

▶ **Suns Eye, Mystery Valley, Arizona.**

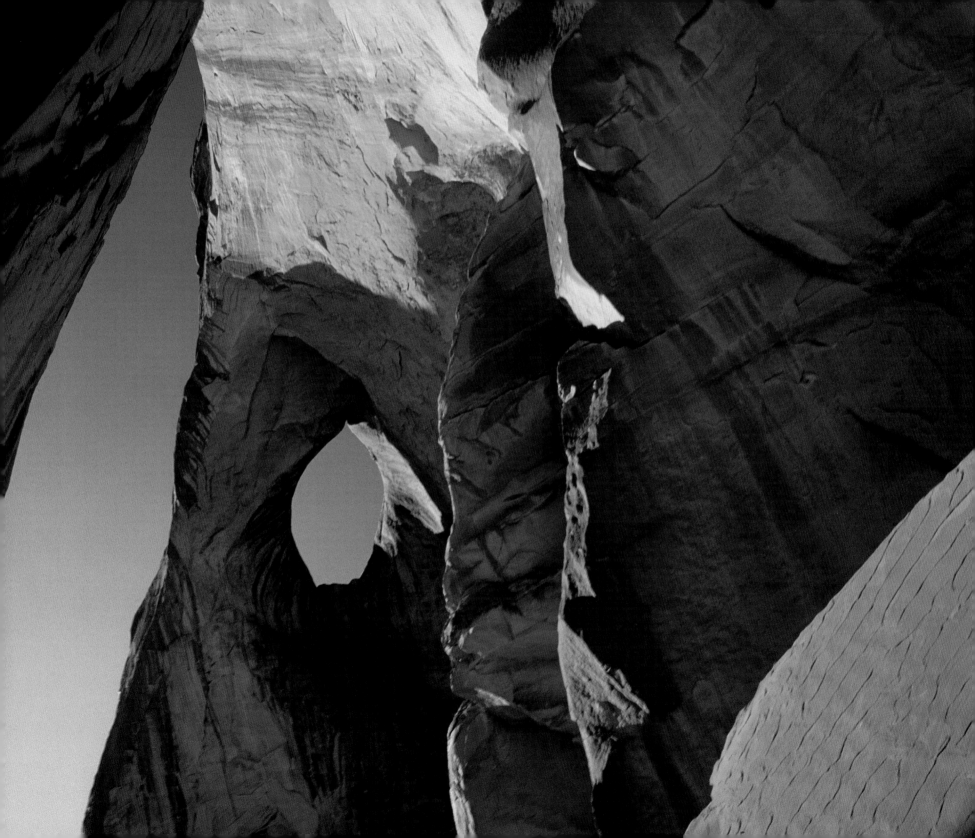

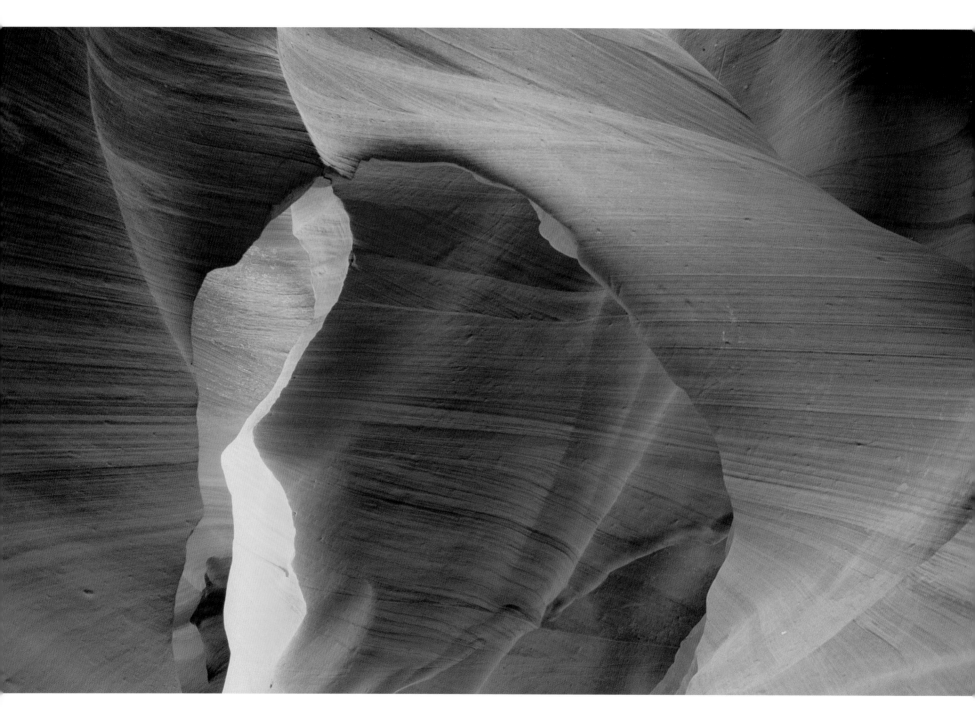

could shape-shift and take the form of animals to do evil. But the topic of *Yenaldlooshi* ("one who trots along here and there on all fours with it") and the bad medicine reported in Clyde Kluckhorn's scholarly work *Navaho Witchcraft* is so taboo among the Navajo that it's not even supposed to be discussed. The skies grew even darker, and the voices grew louder. But I didn't see a thing. I did not see "human wolves" cloaked in coyote skins loping toward me; nor did I see their paw prints on the ground. But I heard the chilling sound of unintelligible voices circling me in the darkness.

I didn't want to wait around to find out whatever was haunting the badlands. But I didn't want to cave into fear, either. I wanted to stare down whatever it was that lurked unseen out there. I stood waiting and fidgeting till nightfall, but the sun I'd hoped for never broke through, and the voices I'd heard finally ran off to the east. I shouldered my camera bag and headed back to my truck in the dark, glancing over my shoulder to see if anyone was following. I traced the same path I'd used earlier. I prided myself in my dead reckoning, but I kept being pulled off course to the south. I steadfastly resisted this pull until I finally saw the silhouette of my truck on the western horizon. I put my water, camera bag, and tripod on the hood. But as soon as I inserted the key in the door, bats started diving at my head. John Steinbeck wrote about bats attacking his shipmate Sparky when they sailed past Tiburon Island five hundred miles southwest of here,

◄ **Window to the underworld, Lower Antelope Canyon, Arizona.**

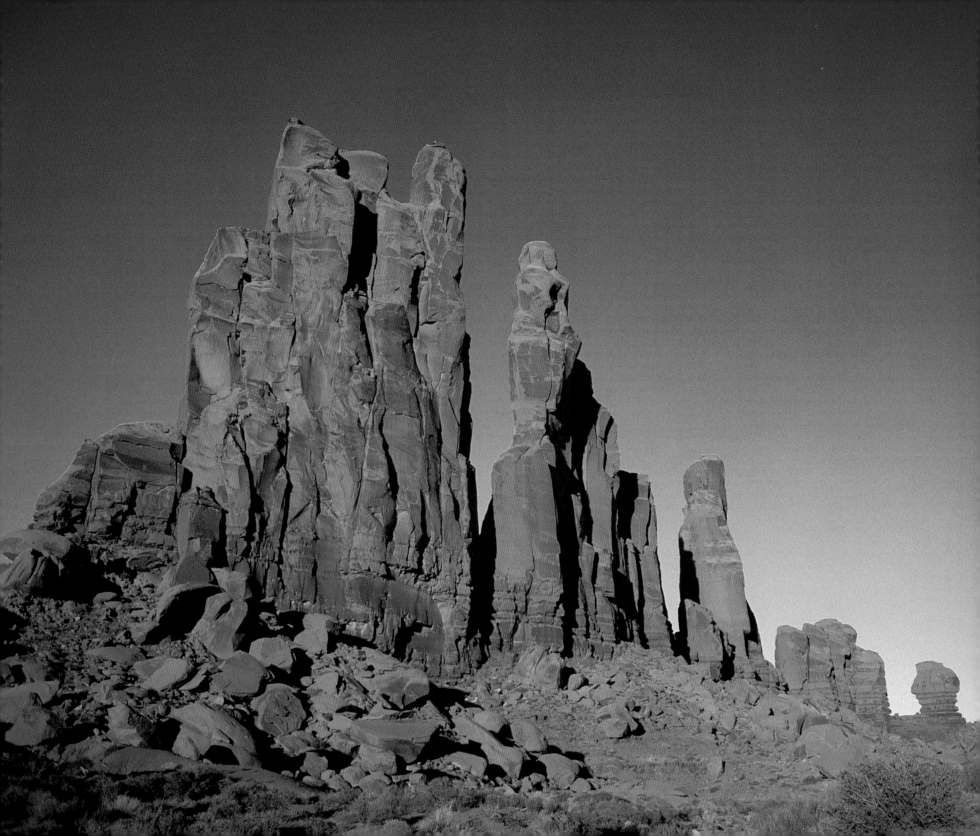

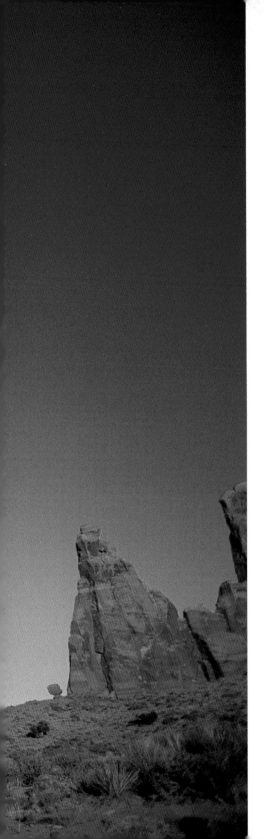

Yei Bichei spires,
Monument Valley,
Arizona.

fifty-seven years earlier. When Sparky accidentally speared a bat in the dark with a trident, Steinbeck warned him not to tell anybody because no one would believe him.

I didn't want to believe what had happened to me in Bistahí, either—and what I've just written isn't the half of it. So I fled the badlands that night and drove across the Painted Desert to Monument Valley, where I stopped and camped for the night. I awoke long before first light and sat on the edge of the mesa, waiting for the sun to come up. Venus hung in the black sky over Mitten Buttes, which clawed out of the landscape like the paws of a great bear. The dark wind soothed me. And the spirit of good and wonder sang from the rays of the rising sun. It set me free from the fear that had struck my heart in Bistahí.

I've gone with the weather and went with the seasons in search of desert light for most of my life. And each journey has brought me discovery of places further toward morning and night. I have wandered among towering monoliths until the sun ignited the spires of the Yei Bichei crimson red, captivated by the Diné (Navajo people) who have sought *hózhó* (balance, beauty, and harmony) from the land they still live in and revere. This was the place I'd finally returned to after so many years, and it welcomed me back home from my journey across America's Outback.

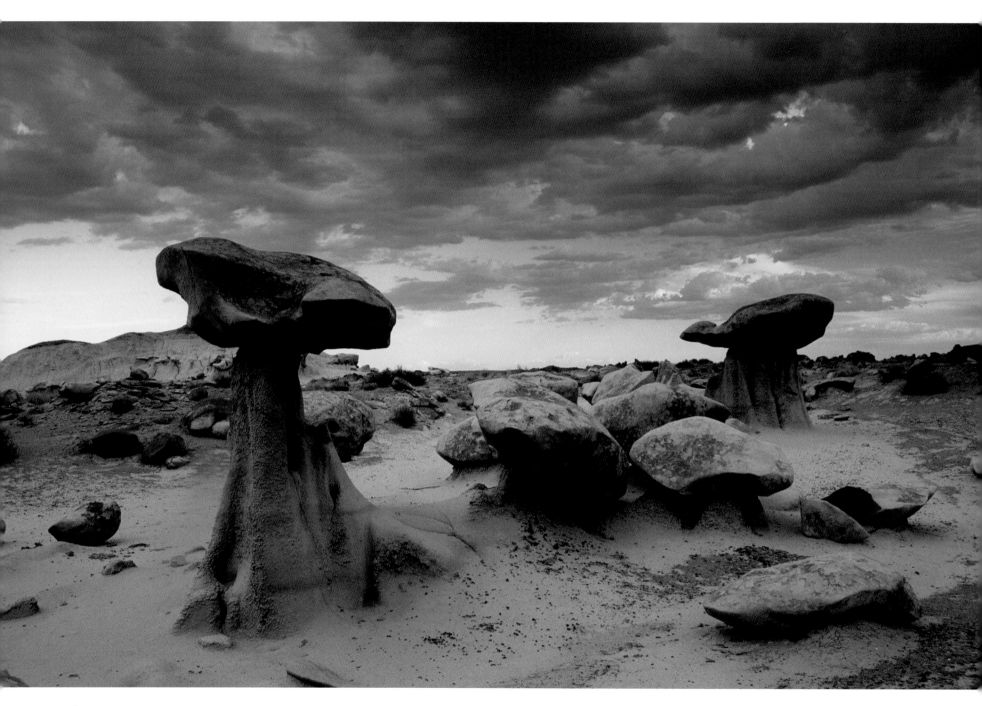

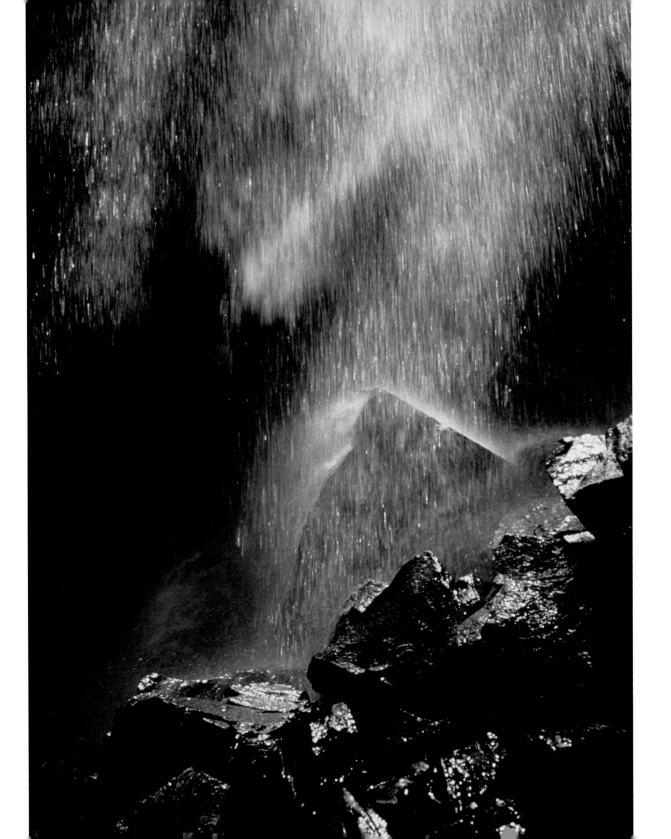

◁ Frijole Falls,
Bandelier, New
Mexico.

◁ ◁ Storm warning,
Bisti Badlands,
New Mexico.

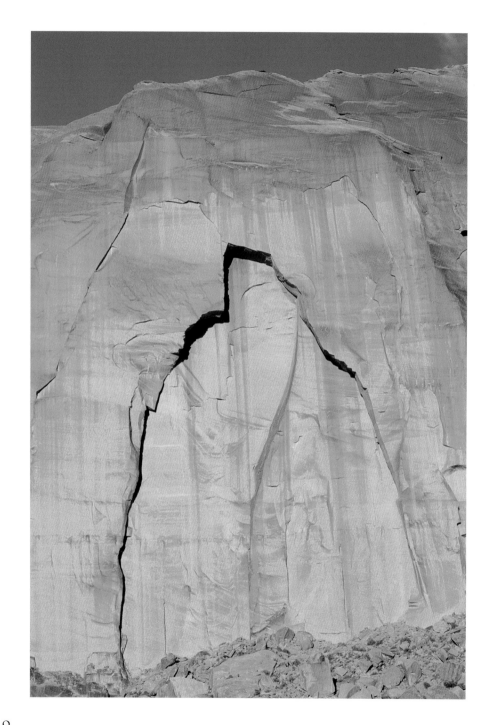

◀ Figure in stone,
Spearhead Mesa,
Monument Valley,
Arizona.

▶ Spearhead Mesa,
Monument Valley,
Arizona.

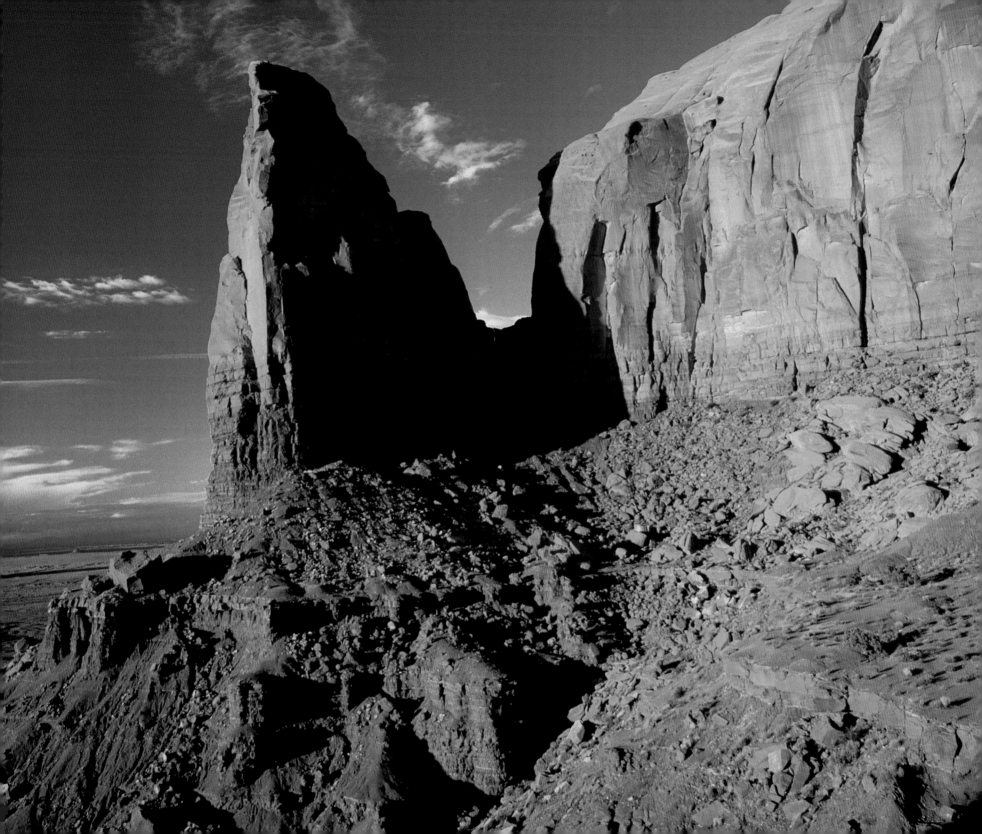

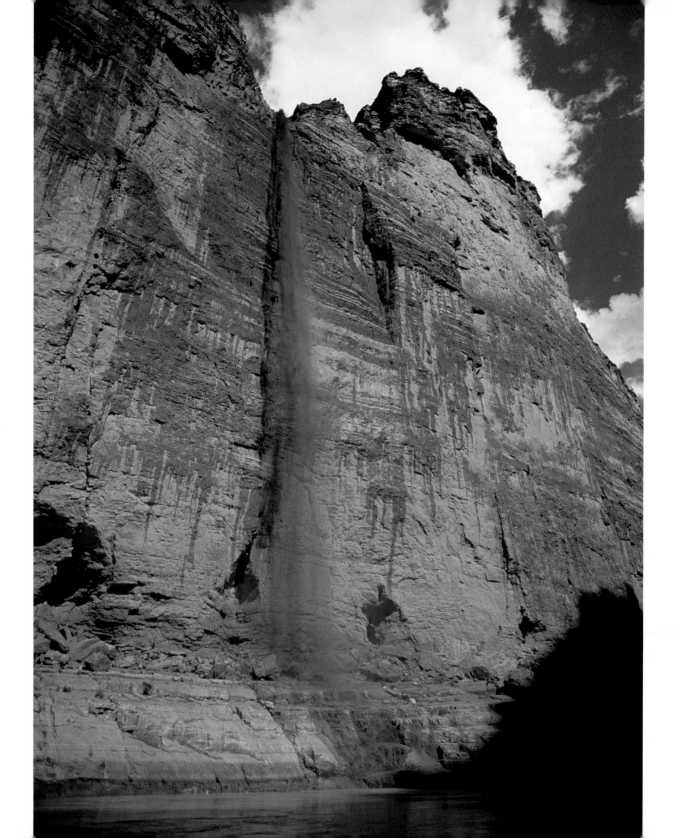

▶ Flash flood, Marble
Canyon, Arizona.

▶ ▶ Palisades of
the Desert, Grand
Canyon, Arizona.

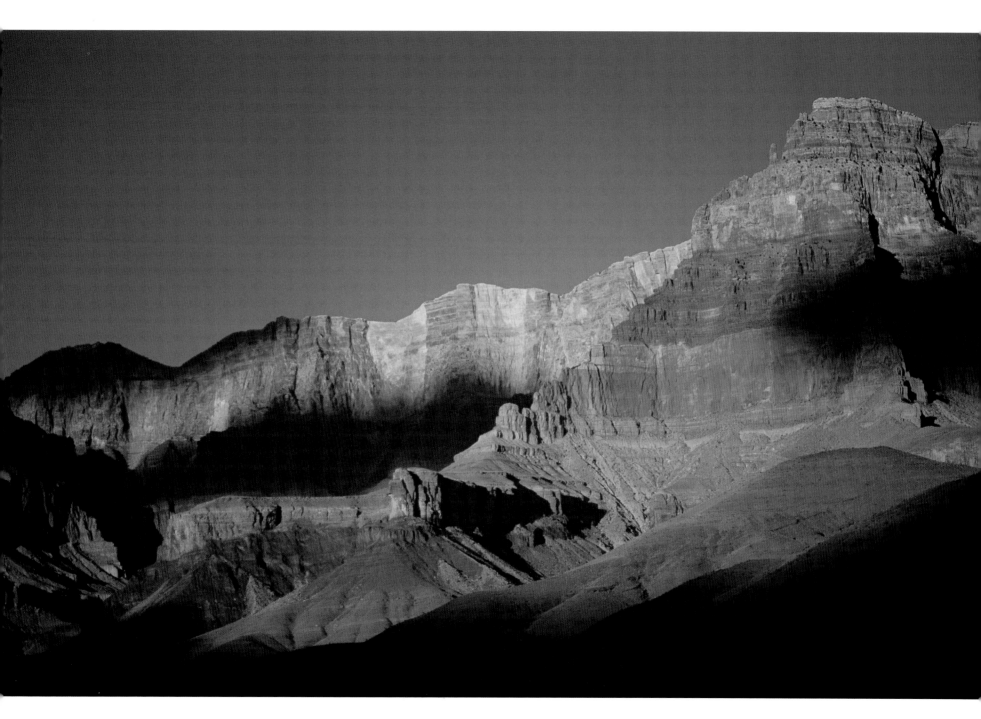

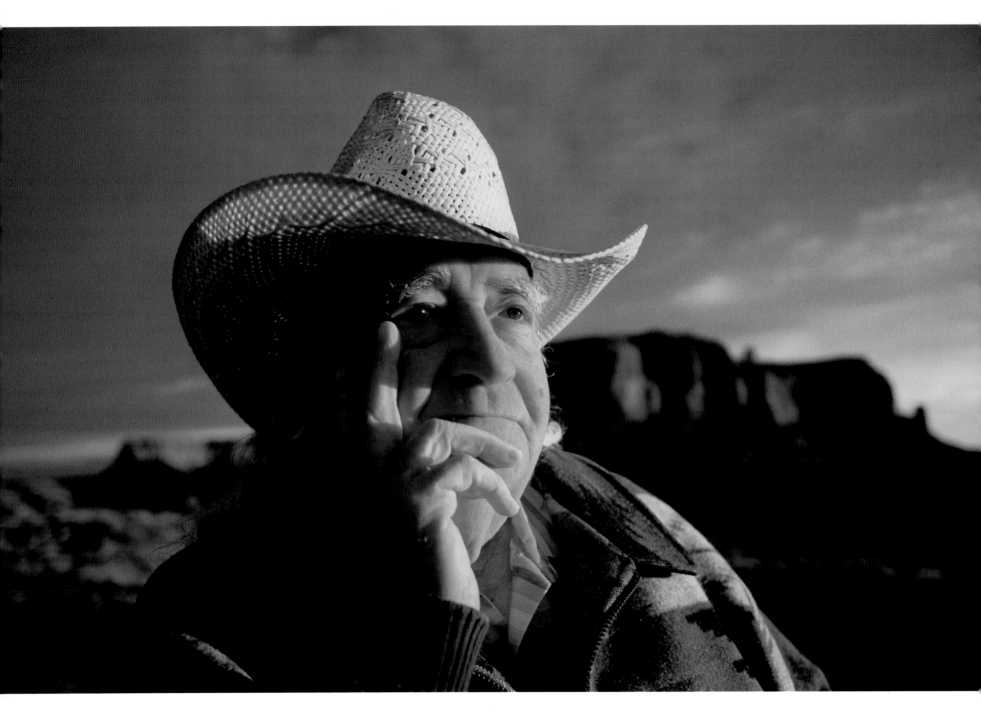

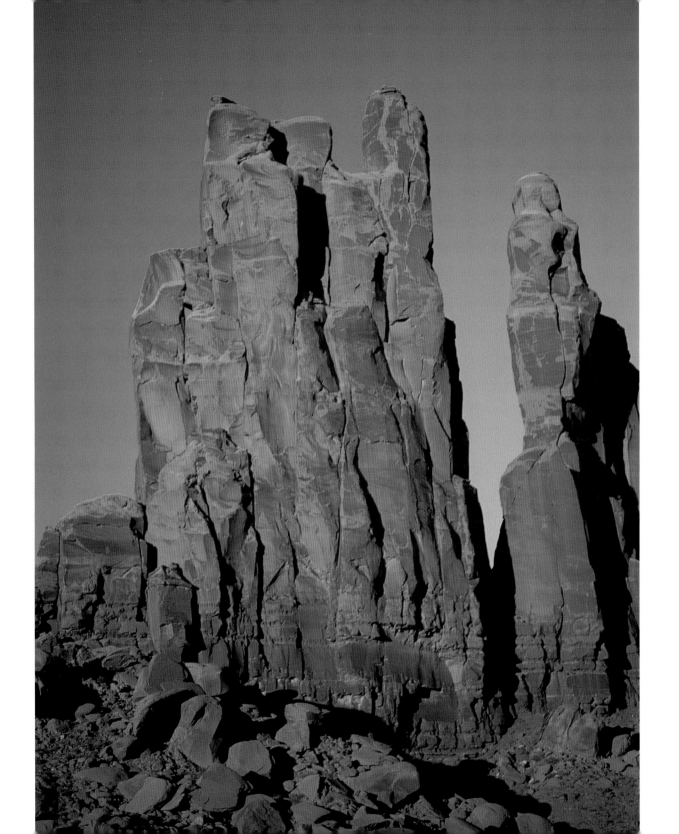

◁ Fire Dancers,
Yei Bichei spires,
Monument Valley,
Arizona

◁ ◁ Bill Crawley in
Monument Valley,
Arizona.

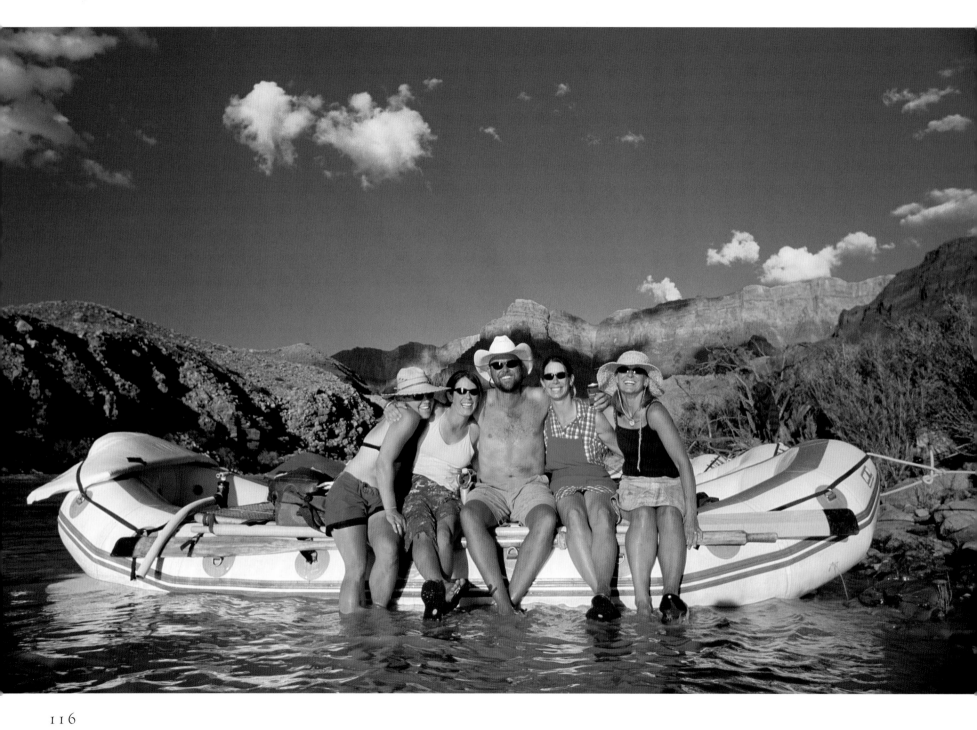

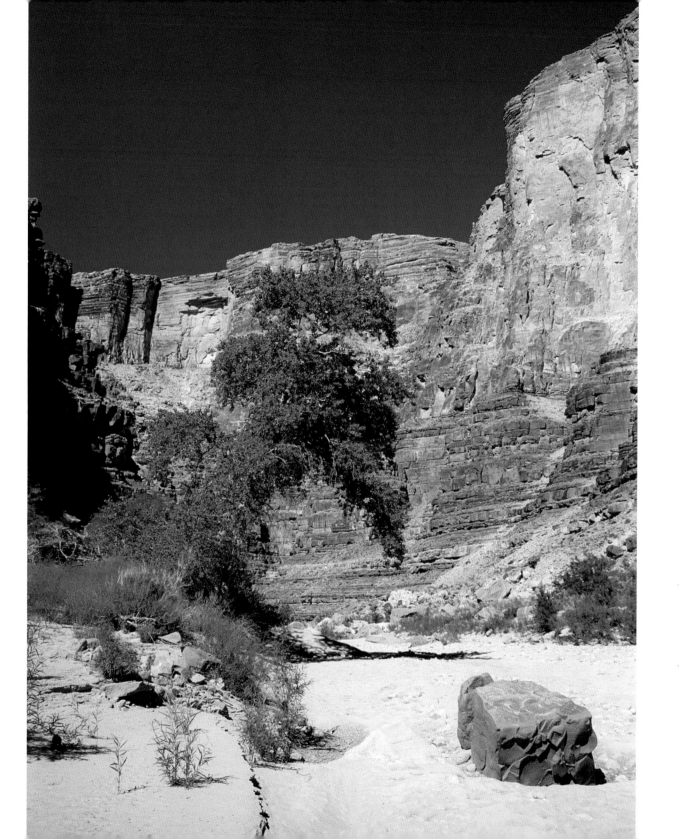

Fremont cottonwood,
Little Colorado
River Gorge, Arizona

AzRA River
guides, Upper
Granite Gorge,
Arizona.

► Suzie Yazzie,
Mystery Valley,
Arizona.

► ► Sunrise, Mitten
Buttes, Monument
Valley, Arizona.

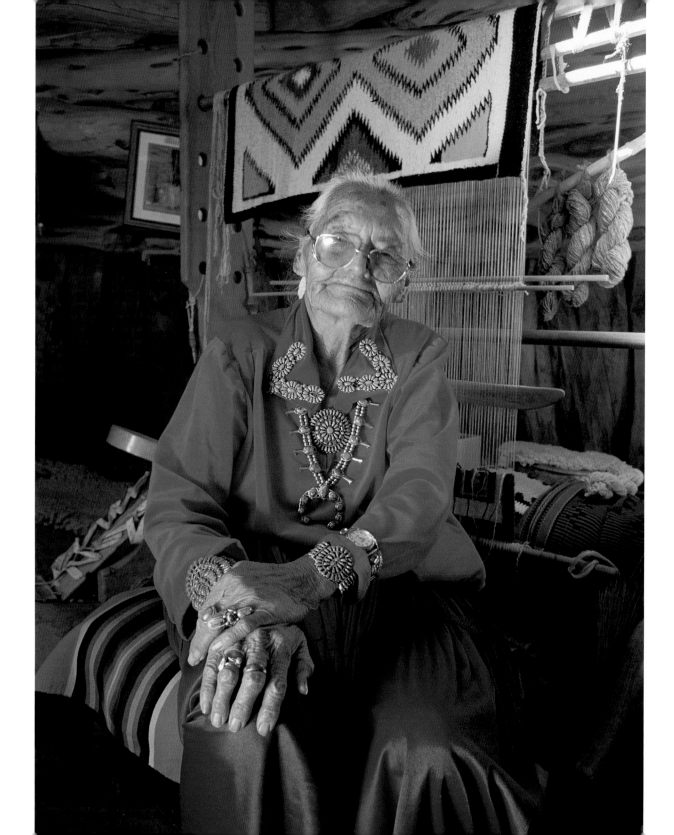

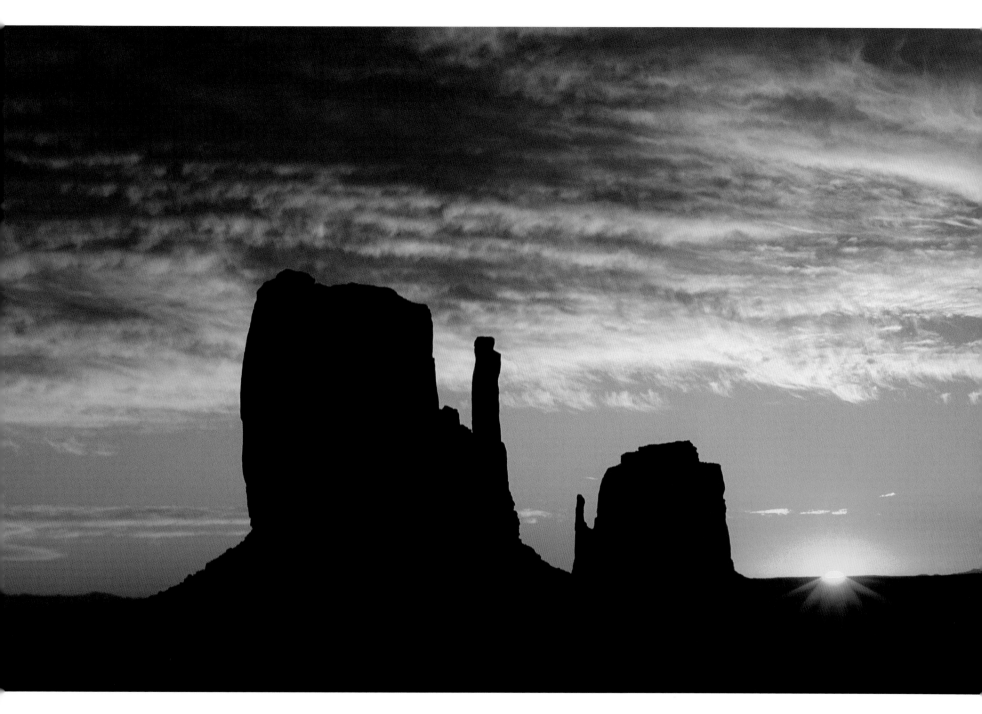

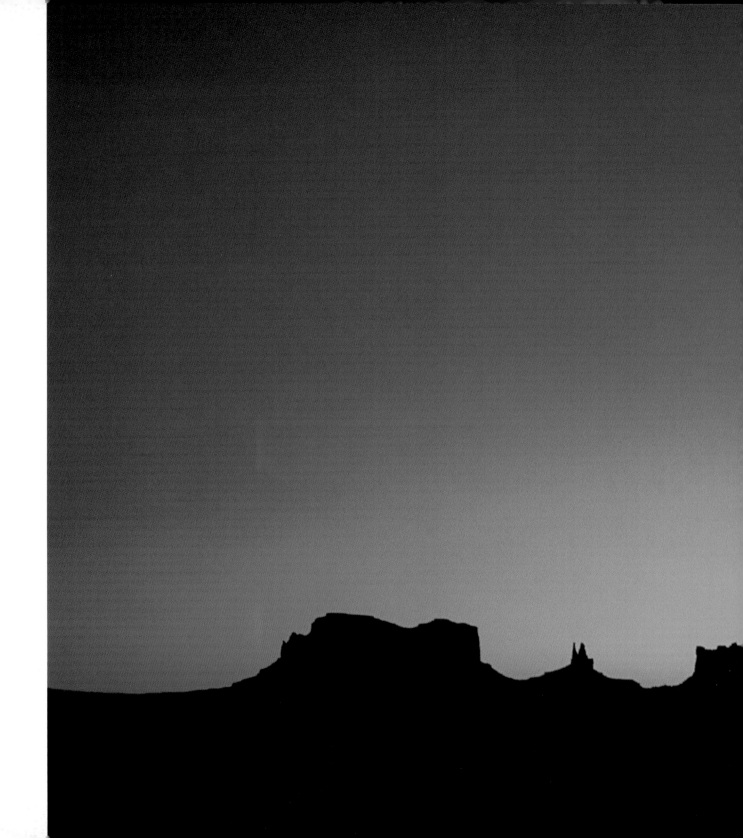

▶ First light, Desierto
Pintado, Arizona.

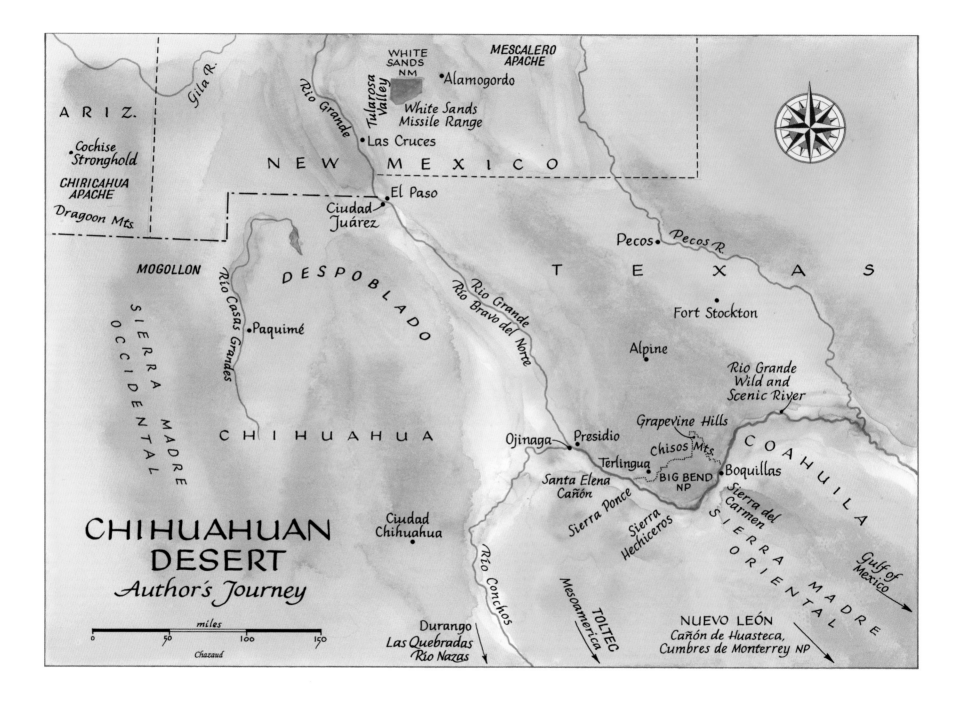

White Sands
NM

MESCALERO
APACHE

•Alamogordo

White Sands
Missile Range

Tularosa Valley

Rio Grande

A R I Z.

Cochise
Stronghold

CHIRICAHUA
APACHE

Dragoon Mts.

•Las Cruces

N E W M E X I C O

•El Paso

Ciudad
Juárez

Gila R.

MOGOLLON

Río Casas Grandes

•Paquimé

S I E R R A

M A D R E

O C C I D E N T A L

D E S P O B L A D O

C H I H U A H U A

Rio Grande
Río Bravo del Norte

Pecos•
Pecos R.

T E X A S

•Fort Stockton

•Alpine

Rio Grande
Wild and
Scenic River

Grapevine Hills

Ojinaga•
•Presidio

Chisos Mts

C O A H U I L A

Terlingua•
•Boquillas

Santa Elena
Cañón

BIG BEND
NP

Sierra Ponce

Sierra del
Carmen

Sierra
Hechiceros

S I E R R A

M A D R E

O R I E N T A L

Ciudad
Chihuahua•

Río Conchos

TOLTEC
Mesoamerica

Gulf of
Mexico

CHIHUAHUAN
DESERT
Author's Journey

Durango
Las Quebradas
Río Nazas

NUEVO LEÓN
Cañón de Huasteca,
Cumbres de Monterrey NP

miles

0 50 100 150

Chazaud

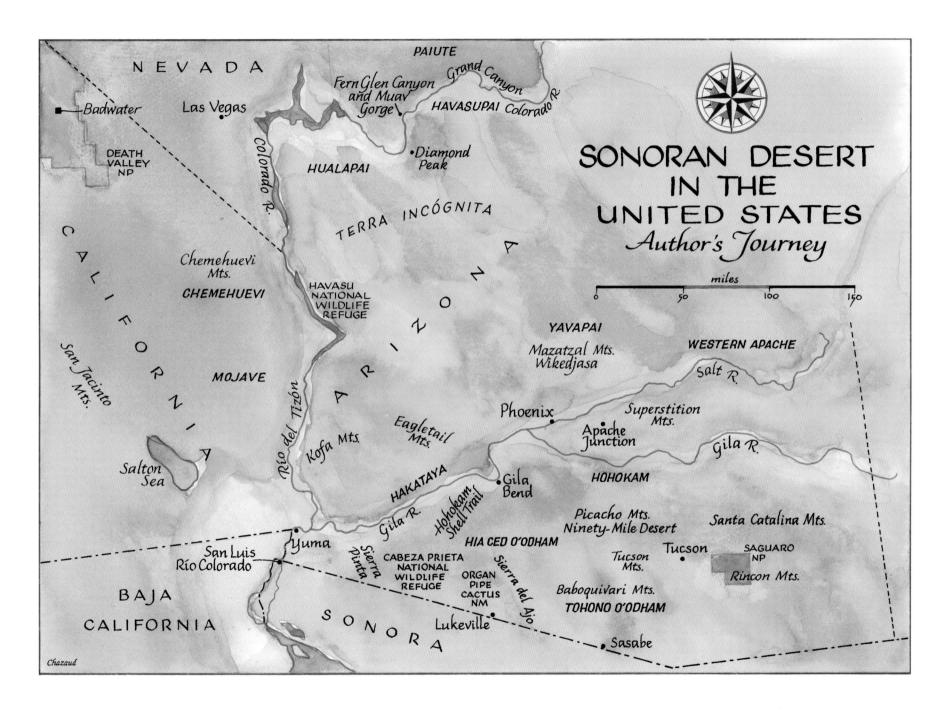

PAIUTE

Grand Canyon

NEVADA

Fern Glen Canyon
and Muav
Gorge

HAVASUPAI Colorado R.

Badwater Las Vegas

DEATH
VALLEY
NP

HUALAPAI

Diamond
Peak

Colorado R.

TERRA INCÓGNITA

SONORAN DESERT
IN THE
UNITED STATES
Author's Journey

miles

0 50 100 150

Chemehuevi
Mts.
CHEMEHUEVI

C A L I F O R N I A

HAVASU
NATIONAL
WILDLIFE
REFUGE

A R I Z O N A

YAVAPAI

WESTERN APACHE

Mazatzal Mts.
Wikedjasa

Salt R.

San Jacinto
Mts.

MOJAVE

Rio del Tizón

Kofa Mts.

Eagletail
Mts.

Phoenix

Superstition
Mts.

Apache
Junction

Gila R.

Salton
Sea

HAKATAYA

Gila R.

Hohokam
Shell Trail

Gila
Bend

HOHOKAM

Picacho Mts.
Ninety-Mile Desert

Santa Catalina Mts.

Yuma

San Luis
Rio Colorado

Sierra
Pinta

HIA CED O'ODHAM

Sierra del Ajo

CABEZA PRIETA
NATIONAL
WILDLIFE
REFUGE

ORGAN
PIPE
CACTUS
NM

Tucson
Mts.

Tucson

SAGUARO
NP

Rincon Mts.

BAJA

CALIFORNIA

S O N O R A

Lukeville

Baboquivari Mts.
TOHONO O'ODHAM

Sasabe

Chazaud

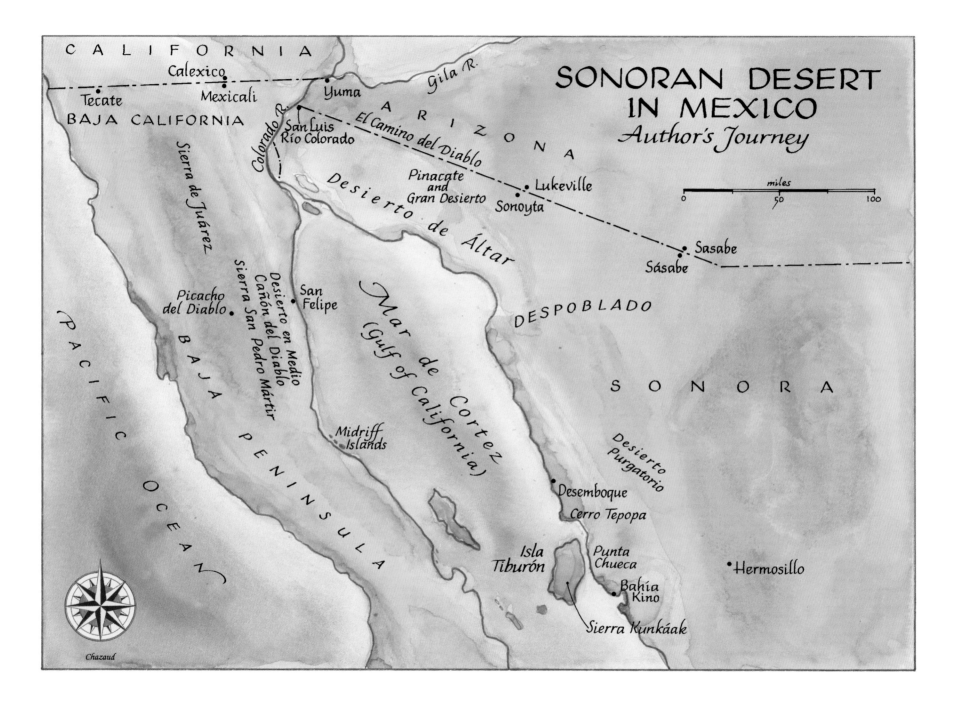

SONORAN DESERT
IN MEXICO
Author's Journey

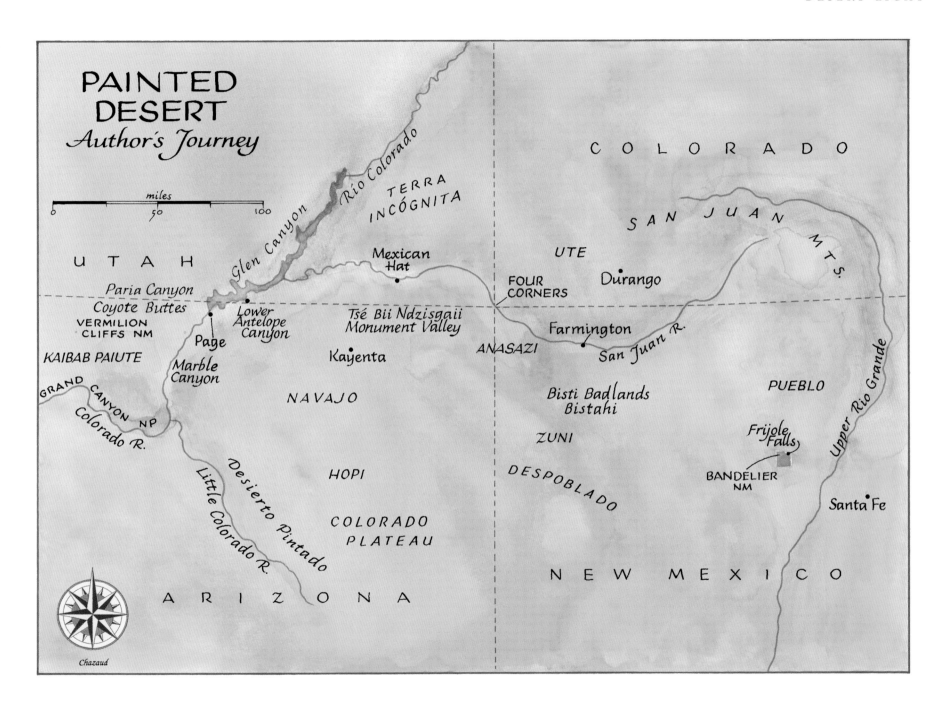

PAINTED
DESERT
Author's Journey

miles
0 50 100

UTAH

COLORADO

Río Colorado

Glen Canyon

TERRA
INCÓGNITA

SAN JUAN

MTS.

UTE

Durango

Paria Canyon
Coyote Buttes
VERMILION
CLIFFS NM

Mexican
Hat

FOUR
CORNERS

KAIBAB PAIUTE

Page

Lower
Antelope
Canyon

Tsé Bii Ndzisgaii
Monument Valley

ANASAZI

Farmington

San Juan R.

PUEBLO

GRAND

CANYON NP

Colorado R.

*Marble
Canyon*

Kayenta

NAVAJO

Bisti Badlands
Bistahi

Upper Rio Grande

*Frijole
Falls*

ZUNI

DESPOBLADO

BANDELIER
NM

Little Colorado R.

Desierto Pintado

HOPI

COLORADO
PLATEAU

Santa Fe

A R I Z O N A

N E W M E X I C O

Chazaud

Selected Bibliography

Abbey, Edward. *Cactus Country* (photographs by David Cavagnaro and others). *The American Wilderness.* 27 vols. Alexandria, VA: Time-Life Books, 1973.

———. *Desert Solitaire: A Season in the Wilderness.* New York: Ballantine Books, 1968.

Annerino, John. *People of Legend: Native Americans of the Southwest* (photographs by the author). San Francisco: Sierra Club Books, 1996.

———. *The Wild Country of Mexico/La tierra salvaje de México,* (photographs by the author, translated by Silvio Sirias). San Francisco: Sierra Club Books, 1994. Bilingual.

———. *Canyons of the Southwest: A Tour of the Great Canyon Country from Colorado to Northern Mexico* (photographs by the author). San Francisco: Sierra Club Books, 1993. Paper edition, University of Arizona Press, 2000.

———. *Adventuring in Arizona.* San Francisco: Sierra Club Books, 1991. 3rd edition, University of Arizona Press, 2003.

———. "People of the Dune: The Seri Indians" (photographs by the author). *Northern Arizona Life,* vol. 2, no. 3, (May 1985): 24–32.

Barnes, Will C. *Arizona Place Names* (revised and enlarged by Byrd H. Granger, illustrated by Anne Merriam Peck). Tucson: University of Arizona Press, 1979.

Bolton, Herbert Eugene. *Spanish Exploration in the Southwest: 1542–1706.* New York: Charles Scribner's Sons, 1916.

———. *Coronado: Knight of Pueblos and Plains* (map by the author). New York: Whittlesey House and Albuquerque: University of New Mexico Press, 1949.

Bones, Jim. *Rio Grande: River to the Sea* (photographs by the author). Austin: Texas Monthly Press, 1985.

Bowers, Janice Emily. *Dune Country: A Naturalist's Look at the Plant Life of Southwestern Sand Dunes* (foreword by Ann Zwinger). Tucson: University of Arizona Press, 1998.

Burdick, Arthur J. *The Mystic Mid-Region: The Deserts of the Southwest* (photographs by C. C. Pierce). New York: G. P. Putnam's Sons and Knickerbocker Press, 1904.

Burrus, Ernest J., trans. and ed. *Wenceslaus Linck's Diary of His 1766 Expedition to Northern Baja.* Los Angeles: Dawson's Book Shop, 1966.

Carmony, Neil B. and David E. Brown, eds. *The Wilderness of the Southwest: Charles Sheldon's Quest for Desert Bighorn Sheep and Adventures with the Havasupai and Seri Indians.* Salt Lake City: University of Utah Press, 1993.

———. *Mexican Game Trails: Americans Afield in Old Mexico, 1866–1940.* Norman, OK: University of Oklahoma Press, 1991.

———. *Tales of Tiburon: An Anthology of Adventures in Seriland.* Phoenix: Southwest Natural History Association, 1983.

Collison, Frank. *Life in the Saddle,* (edited by Mary Whatley Clarke, drawings by Harold Bugbee). Norman: University of Oklahoma Press, 1963.

Coues, Elliott, ed. *On the Trail of the Spanish Pioneer: The Diary and Itinerary of Francisco Garcés (Missionary Priest) in His Travels through Sonora, Arizona and California, 1775–1776.* New York: F. P. Harper, 1900.

Crouch, Brodie. *Jornada del Muerto: A Pageant of the Desert.* Spokane, WA: Arthur H. Clarke, 1989.

Cudahy, John. *Mañanaland: Adventuring with Camera and Rifle through California in Mexico.* New York: Duffield, 1928.

D'Azevedo, Warren L., ed. *Handbook of North American Indians: Great Basin,* vol. 11. Washington, DC: Smithsonian Institution, 1986.

de Niza, Fray Marcos. *The Journey of Fray Marcos de Niza* (edited and translated by Cleve Hallenbeck; illustrated by José Cisneros). Dallas: Southern Methodist University Press, 1987.

Domenech, Abb Em. *Seven Years Residence in the Great Deserts of North America* (woodcuts by A. Joliet). 2 vols. London: Longman, Green, Longman, and Roberts, 1860.

Emery, William H. *Report on the United States and Mexico Boundary Survey,* vol. 1. Washington, DC: Cornelius Wendell, 1857.

Felger, Richard Stephen, and Mary Beck Moser. *People of the Desert and the Sea: Ethnobotany of the Seri Indians.* Tucson: University of Arizona Press, 1985.

Griffen, W.B. "Notes on Seri Indian Culture, Sonora, Mexico." *Latin American Monographs* 10. Gainesville: University of Florida Press, 1959.

Hartmann, Wliiam K. *Desert Heart: Chronicles of the Sonoran Desert* (photographs and maps by the author). Tucson: Fisher Books, 1989.

Hayden, Julian D. "Seri Indians on Tiburon Island" (photographs by the author, designs by Seri children). *Arizona Highways Magazine* vol. 18, no. 1 (January 1942): 22–29, 40–41.

Horgan, Paul. *Great River: The Rio Grande in North American History.* 2 vols. New York: Rinehart & Company, 1954.

Hornaday, William T. *Camp-Fires on Desert and Lava* (photographs by the author, D. T. MacDougal, and J. M. Phillips; map by Godfrey Sykes). New York: Charles Scribner's Sons, 1908. Reissued by University of Arizona Press, 1983.

Ives, Ronald D. *Land of Lava, Ash and Sand: The Pinacate Region of Northwestern Mexico* (maps by the author and Don Bufkin). Tucson: Arizona Historical Society, 1989.

———. "The Legend of the "White Queen" of the Seri." *Western Folklore*, vol. 21, no. 3 (July 1962): 161–164.

Jackson, Donald Dale, and Peter Wood. *The Sierra Madre* (photographs by Dan Budnick). *The American Wilderness.* 27 vols. Alexandria, VA: Time-Life Books, 1975.

Jaeger, Edmund C. *The North American Deserts.* Stanford, CA: Stanford University Press, 1957.

Johnson, William Weber. *Baja California* (photographs by Jay Maisel). *The American Wilderness.* 27 vols. New York: Time-Life Books, 1972.

Klauber, Laurence M. *Rattlesnakes: Their Habits, Life Histories, and Influence on Mankind.* 2 vols. Berkeley: University of California Press, 1984.

Kluckhorn, Clyde M. *Navaho Witchcraft.* Papers of the Peabody Museum of American Archaeology and Ethnology, vol. 22, no. 2. Cambridge, MA: Harvard University, 1944.

Linford, Laurance D. *Navajo Places: History, Legend, Landscape.* Salt Lake City: University of Utah Press, 2000.

Lowell, E. S. "A comparison of Mexican and Seri Indian versions of the legend of Lola Casanova." *The Kiva*, vol. 35, no. 4: (Summer 1970): 144–158, 214–216.

Lumholtz, Carl. *New Trails in Mexico: An Account of One Year's Exploration in North-Western Sonora, Mexico, and South-Western Arizona 1909–1910.* New York: Charles Scribner's Sons, 1912. Reissued by University of Arizona Press, 1990.

Lummis, Charles Fletcher. *A Tramp Across the Continent.* New York: Charles Scribner's Sons, 1892.

MacMahon, James A. *Deserts.* New York: Alfred A. Knopf, 1985.

McPherson, Robert S. *Sacred Land, Sacred View: Navajo Perceptions of the Four Corners Region.* Salt Lake City: Brigham Young University, Charles Redd Center for Western Studies, 1992.

Manje, Juan Mateo. *Unknown Arizona and Sonora: 1693-1721, from the Francisco Fernández del Castillo Version of Luz de Tierra Incógnita,* (Harry J. Karns, trans). Tucson: Arizona Silhouettes, 1954.

McLuhan, T. C., ed. *Touch the Earth: A Self-Portrait of Indian Existence.* New York: Promontory Press, 1971.

Nabhan, Gary Paul. *Gathering the Desert* (illustrations by Paul Mirocha). Tucson: University of Arizona Press, 1985.

North, Arthur W. *Camp and Camino in Lower California.* New York: Baker and Taylor, 1910.

O'Bryon, Eleanor Dart. *Coming Home from Devil Mountain.* Tucson: Harbinger House, 1989.

Ortiz, Alfonso, ed. *Handbook of North American Indians: Southwest,* vol. 10. Washington, DC: Smithsonian Institution, 1983.

Pattie, James Ohio. *The Personal Narrative of James Ohio Pattie* (Timothy Flint, ed.). Cincinnati: John H. Wood, 1831.

Powell, John Wesley. *Explorations of the Colorado River of the West and Its Tributaries: Explored in 1869, 1870, 1871, and 1872.* Washington, DC: U.S. Government Printing Office, 1875.

Reisner, Marc. *Cadillac Desert: The American West and Its Disappearing Water.* New York: Viking Penguin, 1986.

Robinson, John W. *Camping and Climbing in Baja.* Glendale, CA: La Siesta Press, 1983.

Schultheis, Rob. *The Hidden West: Journeys in the American Outback.* San Francisco: North Point Press, 1983. Reissued by Lyon's Press, 1996.

Steele, D. Gentry. *Land of the Desert Sun: Texas Big Bend Country,* (photographs by the author). College Station: Texas A&M University Press, 1998.

Steinbeck, John. *The Log from the Sea of Cortez.* New York: Penguin Books, 1977.

Tyler, Ronnie C. *The Big Bend: A History of the Last Texas Frontier.* Washington, DC: U.S. Department of the Interior, 1975.

Vogt, Evon Z., vol. ed. *Handbook of Middle American Indians.* vol. 8: *Ethnology,* part 2. Austin: University of Texas Press, 1969.

Wheeler, George M. *Report Upon United States Geographical Surveys West of the One Hundredth Meridian.* Washington, DC: U.S. Government Printing Office, 1878.

Wild, Peter, and Neil B. Carmony. "The Trip Not Taken: John C. Van Dyke, Heroic Doer or Armchair Seer?" *Journal of Arizona History,* 34:1 (Spring 1993): 65–80. [On John C. Van Dyke's *The Desert*].

Woodford, A. O., and T. F. Harris. "Geological Reconnaissance Across Sierra San Pedro Martir, Baja California." *Bulletin of the Geological Society of America 49* (September 1, 1938).

Zwinger, Ann Haymond. *The Mysterious Lands: A Naturalist Explores the Four Great Deserts of the Southwest.* Tucson: University of Arizona Press, 1996.

Literature Cited

p. 7 "There was no record but memory and it became tradition." Paul Horgan, *Great River: The Rio Grande in North American History.* New York: Rinehart & Company, Inc., 1954, 13.

p. 11 "Emptiness. There was nothing down there on earth." Marc Reisner, *Cadillac Desert: TheAmerican West and Its Disappearing Water.* New York: Penguin Books, 1986, 1.

p. 12 "It was hard country: nothing nice or comfortable about it." Rob Schultheis, *The Hidden West: Journeys in the American Outback.* San Francisco: North Point Press, 1983, 43.

p. 17 *"Despoblado,"* Fray Marcos de Niza, *The Journey of Fray Marcos de Niza* (edited and translated by Cleve Hallenbeck). Dallas: Southern Methodist University Press, 1987, 4.

p. 17 "We did not think of the great open plains, the beautiful." Chief Luther Standing Bear, *Touch the Earth: A Self-Portrait of Indian Existence* New York: Promontory Press, 1971, 45.

p. 18 "There's something about the desert" Edward Abbey, *Cactus Country.* The American Wilderness series, Alexandria, VA: Time-Life Books, 1973, 156.

p. 27 "At the time it was a veritable "no-man's land." Frank Collison. *Life in the Saddle,* Norman: University Press of Oklahoma, 1963, 207.

p. 55 "Tiburon Island in the Gulf of California has long been shrouded in mystery. . . ." Neil B. Carmony and David E. Brown, *Tales of Tiburon: An Anthology of Adventures in Seriland.* Phoenix: Southwest Natural History Association, 1983, vii.

p. 56 "A curious illusion caused by light and air and moisture." John Steinbeck, *The Log From the Sea of Cortez.* New York: Penguin Books, 1977, 94.

p. 60 "Some of the most inhospitable landscapes in North America." Ray Turner in Carmony and Brown, *Tales of Tiburon,* 59.

p. 64 "None who have ever penetrated into the heart of Tiburon have returned to tell of its wonders. Edward P. Grindell in Carmony and Brown, *Tales of Tiburon,* 59.

p. 66 "One of the hottest and most arid environments." Richard S. Felger and Mary Beck Moser. *People of the Desert and the Sea: Ethnobotany of the Seri Indians.* Tucson: University of Arizona Press, 1985, 98.

p. 95. "Gods sing to you and then drop down a trap door into the past." Schultheis, 47-48.

p. 97. "Ghost places." Robert S. McPherson, *Sacred Land, Sacred View: Navajo Perceptions of the Four Corners Region.* Salt Lake City: Brigham Young University: Charles Redd Center for Western Studies, 1992, 121.

p. 105. "One who trots along here and there on all fours with it." Clyde M. Kluckhorn, *Navaho Witchcraft.* (Papers of the Peabody Museum of American Archaeology and Ethnology, vol. 22, no. 2. Cambridge, MA: Harvard University, 1944), 15.